IMAGES
of America

EARLY
COSTA MESA

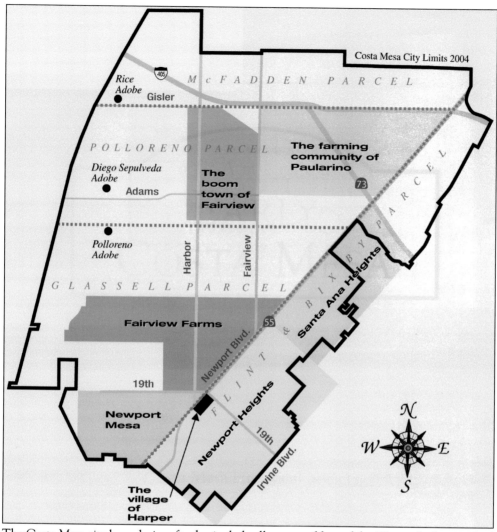

The Costa Mesa city boundaries of today include all or part of four of the 73 parcels that resulted from the partitioning of the Rancho Santiago de Santa Ana in 1868. By 1880, many of the rancho's larger parcels had been subdivided, setting the stage for a land boom that lasted for nearly a decade. In the Polloreno parcel alone, hundreds of land transactions had taken place by 1888. The early communities of Fairview, Paularino, and Harper developed generally through further subdivision of the land into modest-sized parcels that were attractive for family farms, related businesses, and residences. (Map by Keith Hall.)

ON THE COVER: Judge Donald Dodge's children, Donald Jr. and Betty, symbolize the youthful spirit of early Costa Mesa as they show prize-winning apples grown on their family farm. (Courtesy of the Costa Mesa Historical Society.)

IMAGES
of America

EARLY
COSTA MESA

Costa Mesa Historical Society

ARCADIA
PUBLISHING

Published by Arcadia Publishing
Charleston, South Carolina

Printed in the United States of America

Library of Congress Catalog Card Number: 2008933329

For all general information contact Arcadia Publishing at:
Telephone 843-853-2070
Fax 843-853-0044
E-mail sales@arcadiapublishing.com
For customer service and orders:
Toll-Free 1-888-313-2665

Visit us on the Internet at www.arcadiapublishing.com

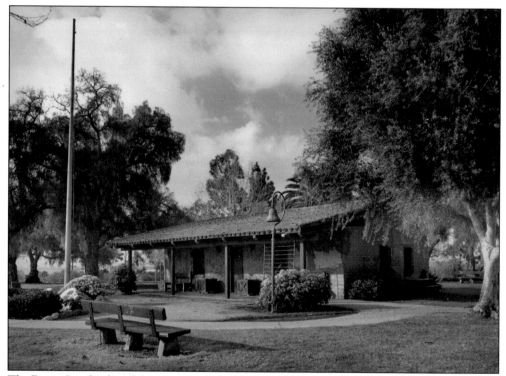

The Diego Sepulveda Adobe was built about 1820 as a way station for cattle herders from Mission San Juan Capistrano. The serendipitous discovery of adobe walls enclosed within a wood-frame ranch house led to the generous donation of the house and surrounding land to the City of Costa Mesa by the Segerstrom family in 1963. Since the adobe's restoration and dedication in 1966, the Costa Mesa Historical Society has operated the adobe (California Historical Landmark No. 227) as a museum. The adobe is located in Estancia Park at 1900 Adams Avenue. (Photograph by Dennis McNutt.)

CONTENTS

ACKNOWLEDGMENTS

Preparing *Early Costa Mesa* for publication has been a journey of rediscovery—particularly for those of us who have worked with the collections of the Costa Mesa Historical Society for many years. We have revisited the events that defined and shaped the early development of Costa Mesa and have scoured the depths of our collections in search of images and documents that would tell the story clearly and succinctly.

Thus the first of our acknowledgments is to all those who have donated materials from their personal and organizational collections to the historical society for preservation and promotion of local history. Without these donations from hundreds of community members and their families, this book would not have been possible.

We have relied heavily on the Edrick Miller collection and upon Ed's seminal book, *A Slice of Orange*. Our community owes a profound debt of gratitude to Ed for researching, collecting, and copying many original photographs and documents and for recording interviews with early settlers. The Costa Mesa Historical Society is privileged to be the repository for Ed's research materials, photographic reproductions, and recordings.

The City of Costa Mesa is acknowledged for its partnership with the historical society since the society's founding in 1966. Our relationship facilitates the preservation and promotion of local history through museum exhibits, cataloged resources, public outreach, and school educational materials. The Costa Mesa Historical Society is pleased to be part of the city's program for enhancing our residents' sense of community.

Several people researched and/or contributed family history items: Keith Hall, Jerry Platt, Richard and Shirlee Opp, Chisholm Brown, Dave Gardner, Dick Stanley, Louise Rusher, and Joyce Brown. Peggy Gardner and Keith Hall created illustrations that we gratefully acknowledge. Unless otherwise noted, all images appear courtesy of the Costa Mesa Historical Society.

Also we wish to thank Prof. Hank Panian for his review and constructive criticism of the manuscript and our editors at Arcadia Publishing for their patience and guidance throughout the creation of this book. We wish to note in particular that editor Jerry Roberts stayed on the telephone answering our questions even while a magnitude 5.4 earthquake shook him for nearly a minute!

—Art and Mary Ellen Goddard
Costa Mesa Historical Society

INTRODUCTION

Some of the earliest remnants of Costa Mesa history were uncovered in April 1935 when archaeologists found evidence of an old Native American village and burial ground on the bluffs above the Santa Ana River near Adams Avenue. This village, called Lukup, was home to hunter-gatherers who subsisted on a diet of acorns, seeds, berries, small game, fish, and shellfish. Although these people left no written history, archaeological evidence obtained since 1935 suggests Native Americans had inhabited the area for more than 3,000 years.

Even though Spain discovered California in 1542, it would be 1769 before an overland expedition, under the command of Don Gaspar de Portolá, passed through the area. In 1810, a soldier in that 1769 expedition, José Antonio Yorba, and his nephew, Juan Pablo Peralta, were granted 62,500 acres in what would become Orange County. Known as the Rancho Santiago de Santa Ana, the acreage was turned to raising cattle in concert with the hide and tallow trade established at Mission San Juan Capistrano. It was during this period that three adobe shelters were built at locations shown on the map on page 2. Of these, only the Diego Sepulveda Adobe survives. This adobe, also known as the Estancia Adobe, serves as Costa Mesa's premier historic building and reminder of the area's early Spanish heritage.

In 1821, Mexico won independence from Spain, and subsequently California came under Mexican control. Cattle herding still was the main activity, but Mexican administration led to more parceling of land, privatization of mission property, and introduction of land inheritance customs that paved the way for the real estate boom at the end of the 19th century. Moreover, ownership of land was hotly contested after Mexico ceded California to the United States in 1848. By 1868, the Rancho Santiago de Santa Ana was split into 73 parcels ranging in size from 25 to 12,155 acres. The present city limits of Costa Mesa include two of these parcels and portions of two others, as shown on page 2. By 1880, a majority of the larger land parcels were subdivided again. Fueled by a Southern California land boom, hundreds of land transfers took place in the area by 1888, ushering in the next chapter in Costa Mesa's history—three early communities.

The boomtown of Fairview, the farming community of Paularino, and the village of Harper once thrived within Costa Mesa's current boundaries. Fairview got its start in 1887 with the help of railroad rate wars. Within a year, Fairview boasted several stores, a post office, newspaper, church, school, three-story hotel, mineral bath, and railroad. Just as quickly, boom turned to bust as the town started into decline in 1889 after the tracks of the Santa Ana, Fairview, and Pacific Railroad were washed out. Meanwhile, the neighboring farming community of Paularino, named after Eduardo Polloreno, continued to maintain its rural atmosphere, consisting of a few scattered farmhouses, a public school, railroad siding, and warehouse. The arrival of retail, commercial, and residential development would have to wait until Costa Mesa annexed the area many years later.

The year 1891 marked the beginning of the village of Harper, named after Gregory Harper Jr., a rancher who came to the area after the Fairview boom. Unlike Fairview, the village of Harper had staying power mainly because of the building of the Santa Ana and Newport Railroad and the arrival of grain farmers. These two factors created enough economic activity to sustain a

local population. After 1906, the impact of land developers and nearby oil discoveries promoted further settlement. Ozment's General Store became the first commercial building in 1908. A year later, Harper's first post office opened. The addition of stores, schools, churches, roads, and water systems gave substance to the village. Streets were laid out, and the beginnings of Costa Mesa became evident. Tracts grew up around the core village. The Fairview Farms, Newport Mesa, Newport Heights, and Santa Ana Heights tracts (see map on page 2) each featured 5-acre plots and their own water distribution systems.

By 1920, the community found itself in want of a new name. First, there was confusion with nearby Harperville, as freight shipments were mixed up. Perhaps more importantly, local leaders wanted a name that would reflect the larger community that had developed. What better way to choose a new name than to conduct a contest, giving everyone a shot at naming the new community? The winner of the $25 prize was Alice Plumer, with her entry "Costa Mesa," a Spanish phrase that translates to "coastal tableland."

During the Roaring Twenties, Costa Mesa continued to grow as the agricultural base shifted to smaller farms and ranches. During 1923, approximately 250 new buildings were erected. In January 1924, the *Santa Ana Register* reported, "Costa Mesa on Highroad to Real City." Costa Mesa soon established its first volunteer fire department and employed its first policeman. As an unincorporated community, Costa Mesa was governed by county supervisors, headquartered in far-off Santa Ana. Local leadership emerged through special districts and organizations such as school boards, water boards, the Costa Mesa Chamber of Commerce, Women's Club, and Lions Club. As early as 1925, the chamber was discussing the concept of home rule. The City of Santa Ana took note of the developing community and launched an annexation attempt in 1928. Local voters turned down the proposal by a 5-1 margin.

Soon afterward, the new community experienced a series of challenges. First, the Great Depression visited Costa Mesa as surely as it visited every community in America. The city slowed down but did not stall. In fact, two new schools were opened by 1931. January 1932 saw a setback with the closing of the Costa Mesa branch of the Bank of Balboa. The effects of the Depression were aggravated at 5:54 p.m. on March 10, 1933, when a severe earthquake shook Orange and Los Angeles Counties. Costa Mesa was hit hard. The epicenter was located about 4 miles southwest of Newport Beach along the Newport-Inglewood Fault. Buildings were severely damaged, but luckily there were no deaths in Costa Mesa.

The community sprang back from this challenge, and even in the midst of business turmoil, the downtown area was rebuilt. Growth was slow but steady. Significant to the area was the commitment of business chains such as Safeway, Alpha Beta, and Red and White stores. Then, just as Costa Mesa was catching its breath, severe rainstorms caused major flooding along the Santa Ana River basin, including the lowland area between the Costa Mesa bluffs and Huntington Beach. Reaching a peak on March 3, 1938, the disaster gave renewed impetus to flood control in the county. Luckily, most of the mesa was spared any lasting damage from the flood. That spirits were not dampened may best be demonstrated by the holding of a Scarecrow Festival sponsored by the chamber of commerce. The first event in June 1938 attracted 5,000 people, with 20,000 attending the following year.

By the end of 1939, Costa Mesa had weathered all storms that had come its way and had begun to assume a special personality and identity. With a growing population of more than 4,000, the stage had been set for what would become the postwar miracle of Costa Mesa.

One

EARLY PERIODS
ON THE MESA

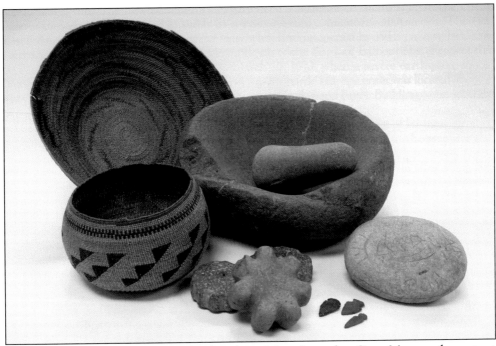

Evidence uncovered in several local archaeological digs shows that Costa Mesa was home to at least two different Native American cultures. These peoples were hunter-gatherers who used stone tools and implements such as the grindstones and arrowheads shown above. Cogged stones, shown at center above, are unique to the region and may have been used during religious or burial ceremonies. Lacking both pottery and metals, native inhabitants often tarred their baskets to hold liquids.

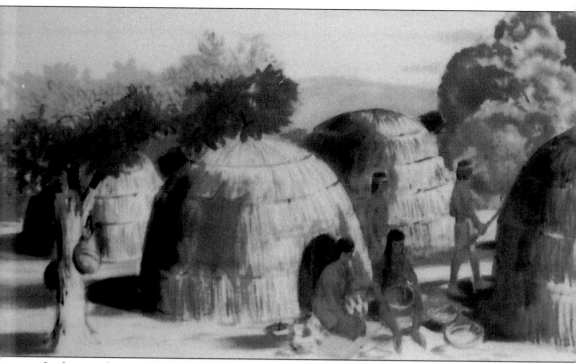

In this mural painted by Richard Garcia Chase, the residents of Lukup go about their daily lives within sight of a double-domed mountain they named Kalawpa (today Old Saddleback). Their wikiups were practical dwellings that, should they become infested with vermin, were burned

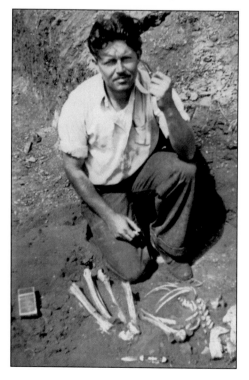

Archaeologist John W. Winterbourne kept detailed notes of the Adams-Fairview excavation during April and May 1935. Along with the Native American skeleton pictured at left, the dig uncovered beads, dishes, tools, ceremonial stones, skulls, and skeletons in an area generally north of the Diego Sepulveda Adobe. The Depression-era excavation was a project of the Works Progress Administration (WPA). (Courtesy of the Pacific Coast Archaeological Society.)

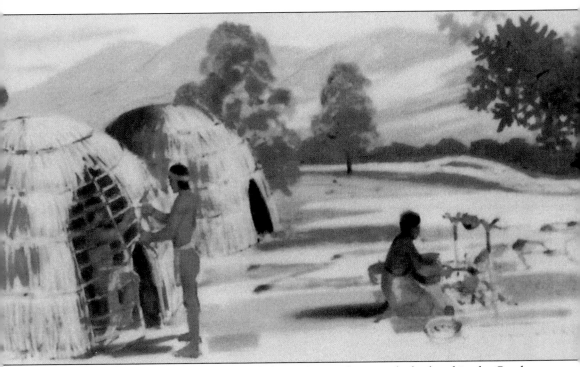

down then rebuilt nearby. Chase painted this and two other murals displayed in the Crocker Bank located at the intersection of Newport and Harbor Boulevards.

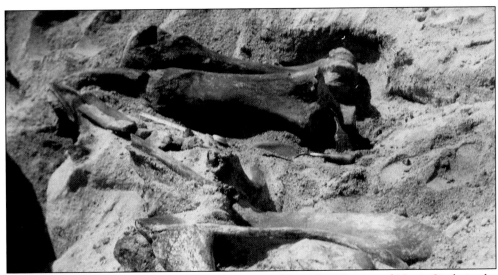

Mastodon bones were found near the intersection of Boa Vista Drive and Nevis Circle in the summer of 1962, as the area was being graded for a housing development. The bones were taken to the Bowers Museum in Santa Ana for further study and then placed on display at local schools. Speculation continues about how the bones arrived in Costa Mesa; did mastodons roam this area or did the remains wash down the Santa Ana River in a past flood?

Artist Richard Garcia Chase depicts a scene at the Diego Sepulveda Adobe centering on ranching activities between 1820 and 1840. The majordomo and a friar confer on the front porch while ranch hands go about their tasks. The adobe structure was built using large "mission" bricks fabricated

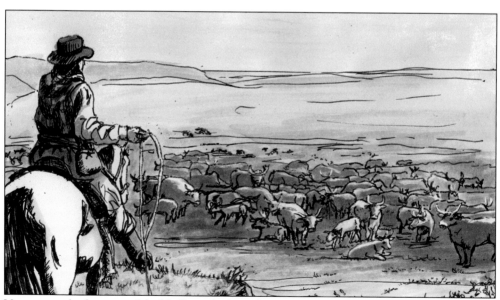

Vaqueros took advantage of the bluffs overlooking the Santa Ana River lowlands to keep a watchful eye on their herds. Shown above is the view looking south from a point near the Polloreno Adobe (see map on page 2). (Illustration by Peggy Gardner.)

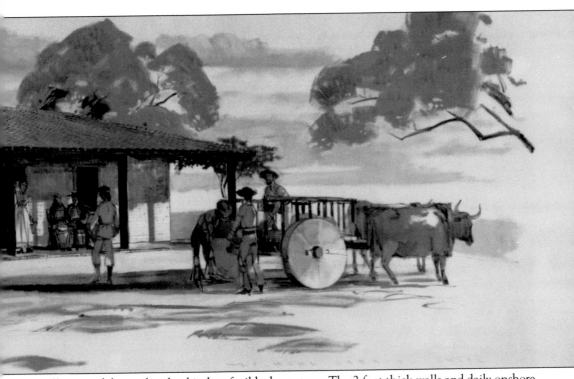

of brown adobe mud with a binder of wild wheat straw. The 2-foot-thick walls and daily onshore breezes kept the building's interior cool during the summer. Chase's mural was displayed at the Crocker Bank at the intersection of Newport and Harbor Boulevards.

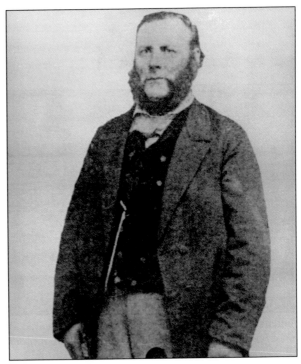

In the years before 1868, when he pastured cattle on the property, Don José Diego Sepulveda made improvements to the adobe that bears his name. Based on Yorba family relationships, he assumed he had clear title to the house and surrounding land. But the District Land Court decided otherwise and in 1868 awarded title to Eduardo Polloreno for 2,760 acres, including the Sepulveda land.

Gabe Allen purchased the 2,760-acre Polloreno parcel in 1870 for $10,500. He is remembered as "an adventurous fellow with myriad interests ranging from seafaring to trading to pioneering." During his 16-year tenure on the parcel, he enclosed the Diego Sepulveda Adobe within a wood frame—an unintended act of historic preservation responsible for the survival of the adobe to this day. Allen's subdivision of the parcel resulted in land transactions that led to the early communities of Fairview and Paularino.

The Bovet family lived in the wood-covered Diego Sepulveda adobe in 1904. Shown here are Frank Bovet with his younger brother on a horse, his mother, Eva, and father, John. In the background are a corner of the adobe and one of the surrounding pepper trees. Frank Bovet recalled there was no refrigeration, so meat was hung in the tree. Under the tree was a hand-powered milk separator that sounded like a siren when cranked at high speed.

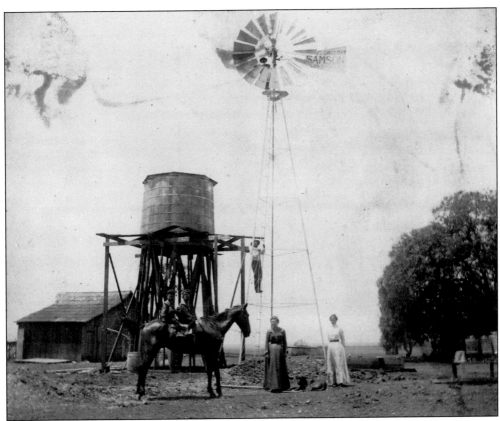

A water tank and windmill served the Bovet family household. A small barn for the family buggy, a watering trough, and milk cans completed the scene.

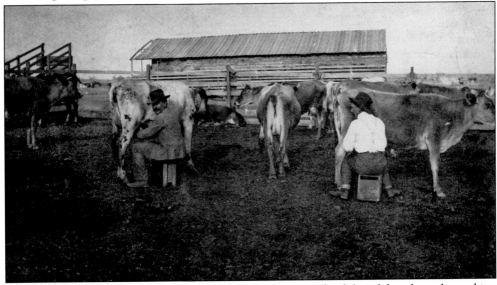

The Bovet milking operation took place in a corral just north of the adobe where the parking lot for Estancia Park is located today. John Bovet (wearing a white shirt) and his father, Augustin Bovet are pictured milking.

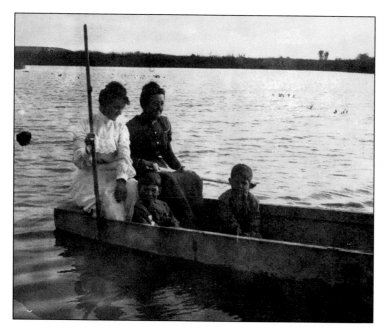

Most of the water in Snow Lake was from an artesian well located on the Snow Ranch adjoining the Bovet farm to the north. The Snow Ranch included a gun club with many duck blinds. The lake had fish—either catfish or carp—that the Bovets fished with a pitchfork. Sitting in the boat are, from left to right, Eva Bovet, her son Frank, the boys' grandmother, Mrs. Augustin Bovet, and Frank's younger brother ? Bovet.

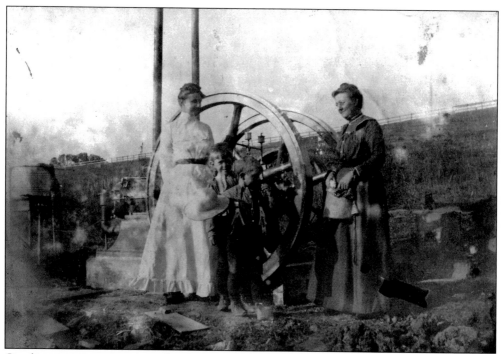

Gasoline engine power was used to pump water from Snow Lake for irrigation of the mesa land. The advantages of gasoline engines were captured in advertisements of the early 1900s: "There's no firing up—no waiting for steam . . . Easily started—no engineer necessary—a boy can operate it." In front of the engine is the same group of Bovets pictured above.

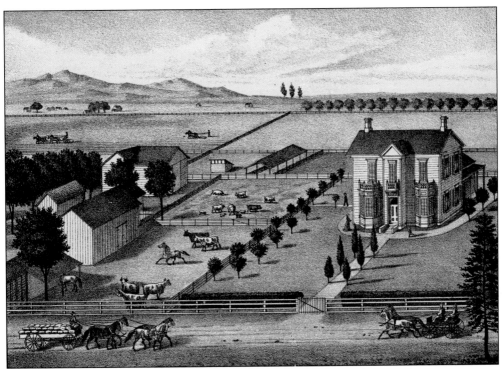

Captured in this late-1870s illustration is the Hubert H. Wakeham farm located on 208 acres that Wakeham purchased from James McFadden for $2,600. The farm was located just south of today's Sunflower Avenue between Fairview Road and Bear Street. After Wakeham died in 1888, his wife, Elizabeth, ran the farm and raised their six children. The Wakeham family constitutes one of the longest unbroken chains of land ownership in Costa Mesa; Wakeham Park and Wakeham Well are named after them. (Illustration from Thompson and West's *History of Los Angeles County*, 1880.)

An artesian well forms the focal point of this *c.* 1900 outing on the Wakeham farm. Artesian wells were a common source of water for area farms through the early 1900s. Water pressure was sufficient to push water to the second story of the Wakeham farmhouse. Corn seen growing in the background was used to feed the Wakehams' hogs.

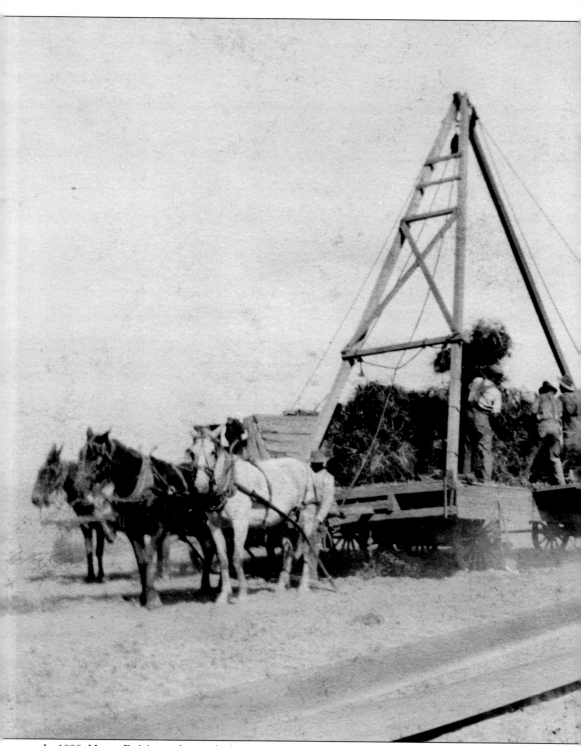

In 1898, Henry D. Meyer obtained a long-term lease for 3,000 acres bounded by the Gabe Allen ranch to the north, today's Newport Boulevard to the east, Nineteenth Street to the south, and the Santa Ana River to the west. According to Henry's son Irving Meyer, "We raised barley, wheat,

and oats—also had many hogs and cattle. After a few years we also raised beans, corn, sugar beets, and vegetables." Shown here is one of Meyer's threshing operations in the early 1900s.

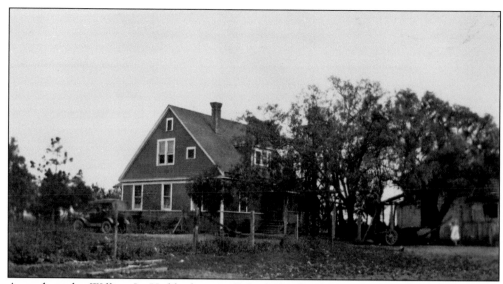

An early settler, William Im Hof, had originally built this farmhouse in 1892 near the intersection of today's Placentia Avenue and West Nineteenth Street. In 1903, Henry Meyer purchased the Im Hof acreage and moved the house 2 miles north to the location pictured above near the Polloreno Adobe (see map on page 2).

The Polloreno Adobe fell into ruin by 1906 after Henry Meyer allowed treasure seekers to dig around the old building for hidden gold. Clearly evident is erosion of the adobe bricks caused by exposure to the elements. The same fate might have befallen the Diego Sepulveda Adobe was it not for the wood framing built around it by Gabe Allen in the mid-1870s.

Two

EARLY COMMUNITIES
FAIRVIEW

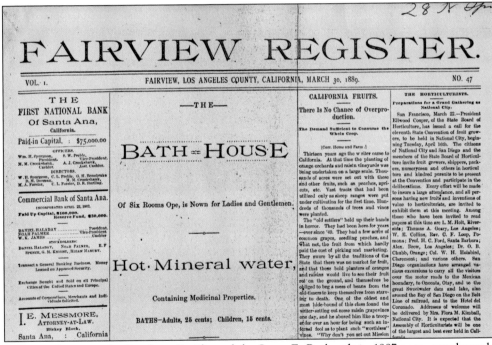

Rate wars between the Southern Pacific and the Santa Fe Railroads in 1887 encouraged people to come to Southern California. One of the resulting boomtowns was Fairview, which grew from prospectus to reality between the fall of 1887 and mid-1888. A syndicate of investors purchased 1,763 acres centered on the present-day intersection of Harbor Boulevard and Adams Avenue and laid out the town on a grand scale, featuring a 100-foot-wide main boulevard and small tracts of 2.5 to 10 acres. One of the investors established the town's newspaper, the *Fairview Register*, in May 1888. The newspaper was unabashedly promotional of all things Fairview, with hard news such as the impending division of Los Angeles County to form Orange County reserved mainly for editorial columns on page 2.

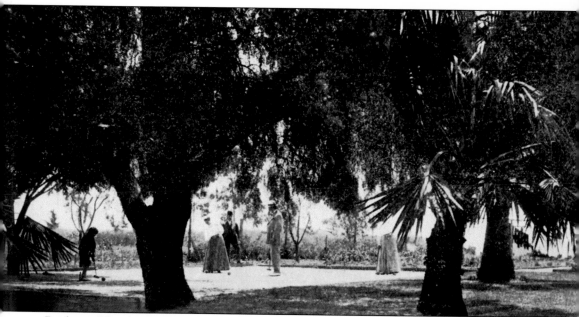

By the middle of 1888, Fairview boasted several stores, a post office, newspaper, church, school, railroad, three-story hotel, and mineral baths. But by May 1890, the downtown had collapsed and the original investors had sold out. In 1891, the hotel was moved four blocks to a location just across the street from the mineral baths, near the intersection of today's Merrimac Way and Harbor Boulevard. In 1903, the hotel changed hands and major renovations were undertaken,

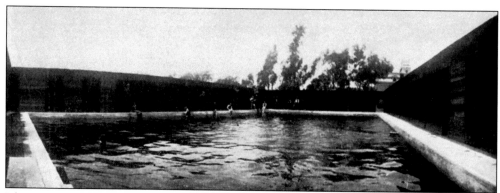

The swimming plunge at Fairview Hot Springs measured 60 by 100 feet and offered mineral water at a consistent temperature of 90 degrees Fahrenheit. Analytical chemist Dr. Julius Koebig prepared an analysis of the spring water in October 1904. Perhaps the doctor's analysis led the hot springs proprietor to claim bathing in the mineral water would "cure rheumatism, neuralgia, gout, and general debility as well as all blood and skin diseases." To the right, above the pool enclosure, a portion of the hotel can be seen just across the street.

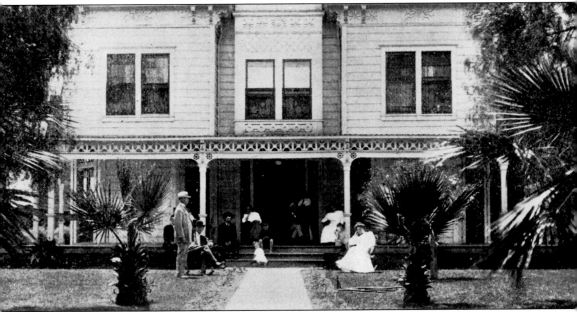

resulting in the Fairview Hot Springs Hotel pictured above. The hotel offered a picturesque location, home-style cooking, sports, and amusements—all at the attractive rate of $10 per week and up for first-class accommodations. The hotel soldiered on for several more years with multiple changes of ownership until it ended up as a private residence.

By 1911, all that remained of Fairview were a few scattered houses, a schoolhouse, and the Hot Springs Hotel shown above. The hotel had changed hands several times since 1906, with each new owner unable to sustain a successful business. An earthquake in 1918 cut off the flow of mineral water—the hot springs were no more. The hotel was sold at auction in 1920 to Charles TeWinkle, who would become Costa Mesa's first mayor many years later. Lumber and fixtures from the hotel were used to build several area homes.

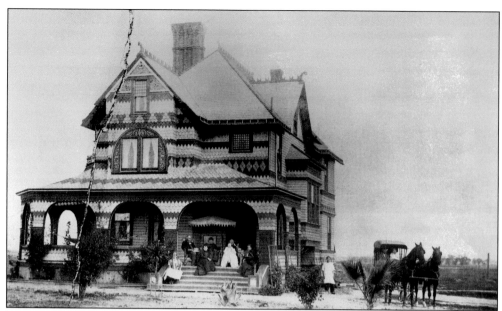

Even as the land boom cooled off, the Fairview Development Company continued to promote the area. George Clark from Chicago built this $12,000 home north of today's Baker Street in 1889. According to John Gee Clark, who was born in the mansion in March 1890, the first floor included a parlor, reception hall, library, dining room, pantry, and kitchen. There were four bedrooms and a bathroom on the second floor, while the third floor consisted of servants' quarters. John's grandparents lived in a cottage due east of the main house.

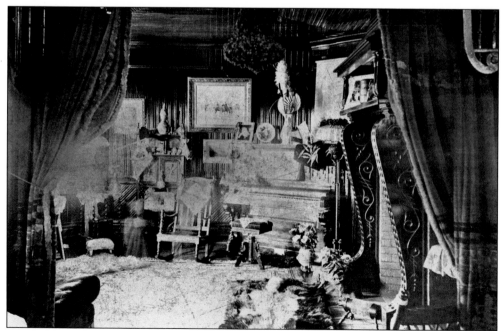

The parlor of the George Clark home featured polished redwood and a massive fireplace, as shown in this 1890s photograph. The home was located near the intersection of today's Watson Avenue and Fernheath Lane.

According to the *Fairview Register* of March 30, 1889, Charles H. Stanley had visited Fairview for two months and was traveling back to Worcestershire, England, to look after his interests there prior to returning with his family "to his new home in this sun-kissed land of health, wealth and flowers by the sea in America." The Stanley family did return later in 1889 and soon posed for this photograph taken at the B. F. Conaway studio in Santa Ana.

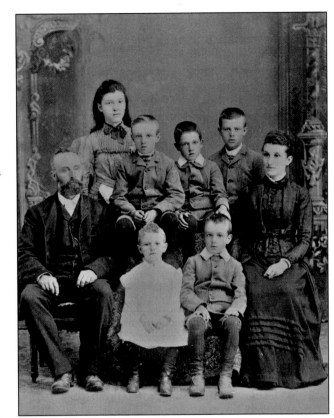

Samuel Gisler (namesake of today's Gisler Avenue) immigrated to Oxnard, California, from Switzerland in 1883 in search of "possibilities not to be hoped for in his native land." He arrived in the Fairview area in 1903 and successfully farmed 250 acres of beets, 70 acres of barley, and 30 acres of alfalfa, along with running a small herd of 11 dairy cows.

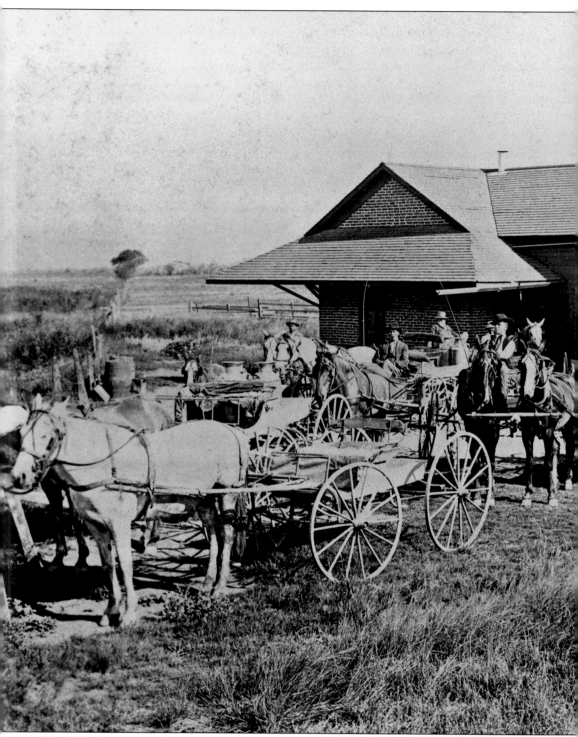

H. A. Bingham opened the Fairview Creamery in 1892 and soon had all the local dairymen bringing their milk to his business. During its heyday (above), the creamery took in about 1,000 pounds of milk daily at its location on the west side of today's Fairview Road just opposite Paularino

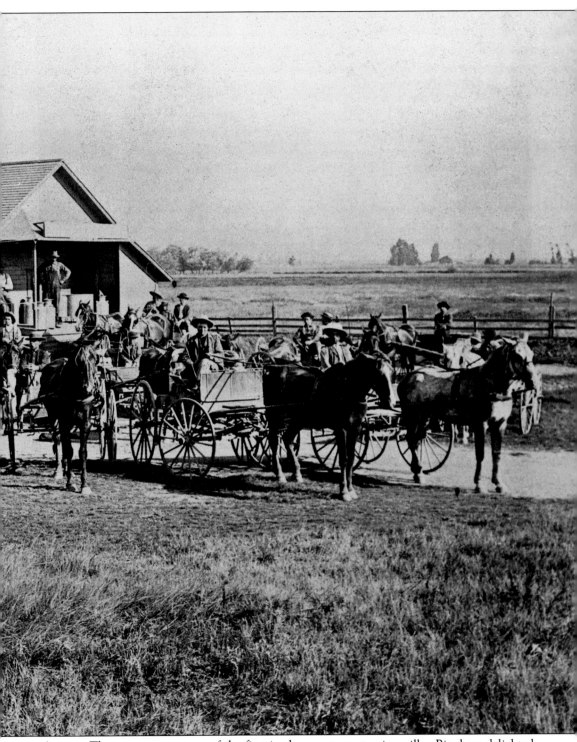

Avenue. The creamery was one of the first in the area to pasteurize milk—Bingham delighted in showing the equipment to visitors. After operating for several years, the creamery went out of business about 1900.

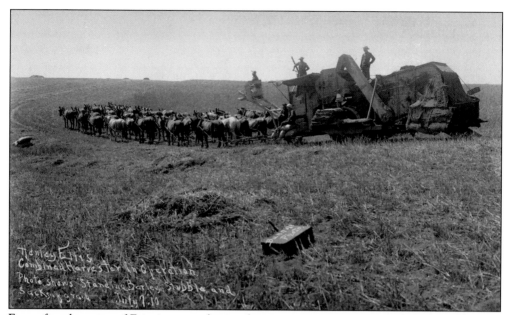

Even after the town of Fairview went bust, a farming community remained. One of the area's large-scale farmers was Henley Ellis, shown here threshing barley using his combined harvester on July 7, 1910. Grain was shipped out of the area via warehouses and a railroad siding at Thurin, near the intersection of today's Newport Boulevard and Fairview Road.

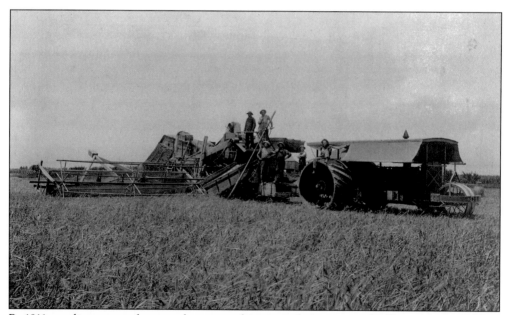

By 1911, gasoline-powered tractors began to achieve popularity not reached by steam power. Here a large tractor manufactured by C. L. Best Tractor Company of San Leandro, California, pulls Henley Ellis's combined harvester rig. Apparently enamoured with gasoline power, Ellis owned one of the first automobiles in the area and achieved notoriety racing against Barney Oldfield.

Twentieth-century farming made steady progress from horse teams to tractors and from manual labor to mechanization. These trends are illustrated in this 1920s photograph of threshing operations and crew taken west of Fairview below the bluffs overlooking the Santa Ana River.

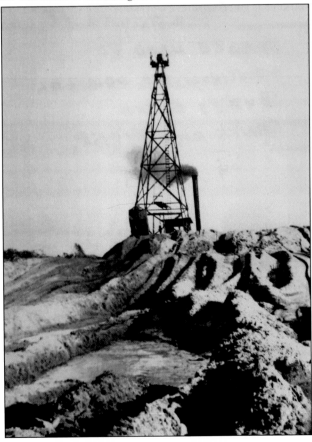

Considering the Santa Ana River watershed drains approximately 2,800 square miles and drops more than 11,000 feet in elevation, one can imagine the power of the river to shape the landscape at its lower reaches as it flows along the boundary between Costa Mesa and neighboring Huntington Beach. The original levees on the Santa Ana River were constructed by dredges such as that shown at work in this 1920s photograph. The levees notwithstanding, in 1928, the U.S. Army Corps of Engineers declared the watershed to have the greatest flood potential west of the Mississippi River.

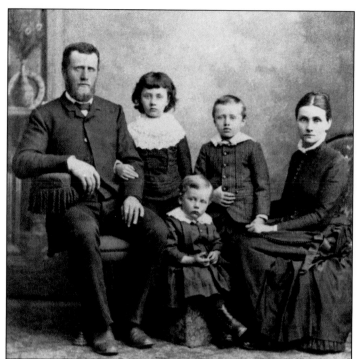

Another family with a long chain of land ownership in the area is the Cornelius M. McClintock family. The McClintocks came from Iowa to Los Angeles, Greenville, and finally to Fairview in 1903. McClintock was killed in 1915 when his car was hit by a Pacific Electric train at the Greenville Crossing. He was deaf and thus did not hear the approaching train's whistle.

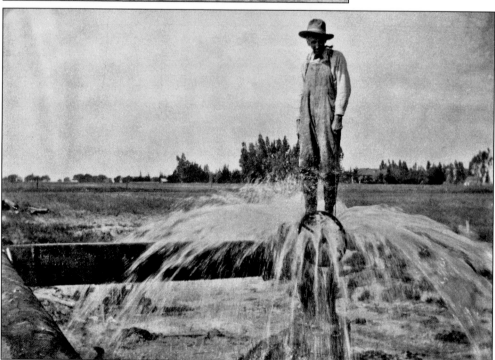

Cornelius McClintock donned his boots for this photograph taken at his artesian well in Fairview about 1906. The well was 444 feet deep, penetrating successive strata of water-bearing gravel. Water delivery rate was 70 miner's inches, equivalent to 10.5 U.S. gallons of water per second, using the Southern California definition of miner's inch.

The McClintock Dairy was located on a 90-acre property on the southwest corner of what is now Fairview Road and Baker Street. Purchased in 1905, the farm included the Victorian home shown here. The dirt road in the foreground is today's Baker Street. In 1930, the home was torn down and a new Spanish-style home was built nearby—the latter home still stands today.

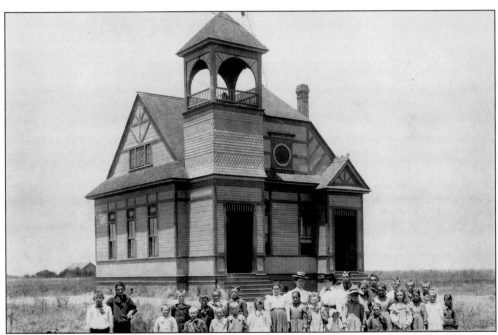

Although the business center had collapsed a year earlier, Fairview citizens decided to go ahead with building a new schoolhouse. Construction started in April 1891 and was completed for the first class that September. Shown here is the Fairview School class of 1897, with teacher Eleanor Stanley at the center wearing a light-colored straw hat. The school was located just west of the intersection of today's Pinecreek Drive and Adams Avenue.

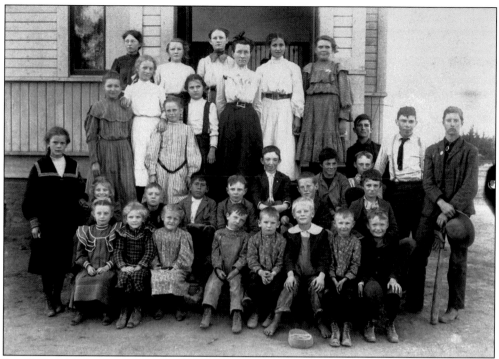

Enrollment at Fairview School ran between 25 and 35 students for much of its 24-year history. The class of 1906 shown here with their teacher, Helen Hack, included several of the area's pioneer family names: Baker, Chatterton, Platt, Meyer, and Liebermann.

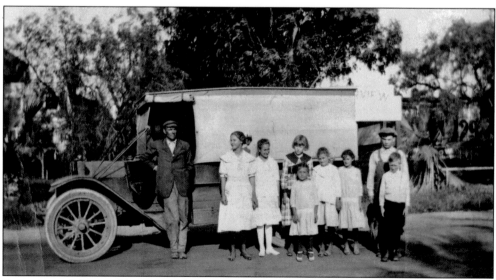

Formation of the neighboring Paularino School District in 1913 cut enrollment at Fairview School by half. Before the fall of 1915, Fairview School closed and students were bused south to Harper School, located at the intersection of today's East Seventeenth Street and Orange Avenue. Shown here is the area's first school bus, with driver Walter W. Middleton and eight students from Fairview. The defunct Fairview Hotel appears in the background to left.

Three

EARLY COMMUNITIES
PAULARINO

When Gabe Allen sold 1,006 acres of the Polloreno tract to Henry Berry in 1875, the stage was set for emergence of another early community, Paularino. Named for Eduardo Polloreno, the new community received its first settlers in 1886, after Henry Berry's widow, Elizabeth, subdivided the Berry Rancho. Paularino consisted of approximately 800 acres bounded as shown on page 2. Pictured here in temporary quarters are Mr. and Mrs. Fred Chatterton (to the left), early settlers from Boston, Massachusetts. They moved to Southern California for Mrs. Chatterton's health, bought 10 acres from Elizabeth Berry and built a house on the northwest corner of today's Yellowstone Drive and Paularino Avenue.

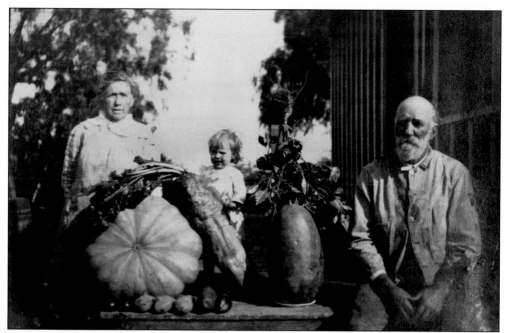

The John A. Shiffer family, including son Jake, arrived in Paularino from Kansas in 1910. Perhaps a print of this photograph showing the bountiful harvest of garden vegetables was sent back home to family and friends. The Jake Shiffer farm, near the corner of today's Bear Street and Paularino Avenue, was one of the last remnants of the community, disappearing in early 1973 to make way for the 73 Freeway. Even then, Jake and his wife, Grace, moved only a short distance to the renovated old Paularino schoolhouse, located across Bear Street from today's Shiffer Park.

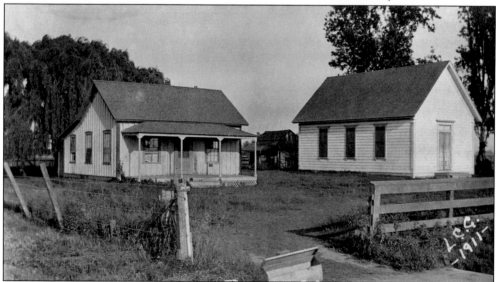

Since there was no business center in Paularino, local farmers had to trade at the general store in Fairview or at one of several stores in the Santa Ana area. Similarly, there were no local churches, so Paularino folks frequented the Greenville Church. Pictured above is the church to the right and parsonage to the left around 1911. The old church still stands today at 3501 South Greenville Street, Santa Ana, just a few blocks north of the Costa Mesa city limits.

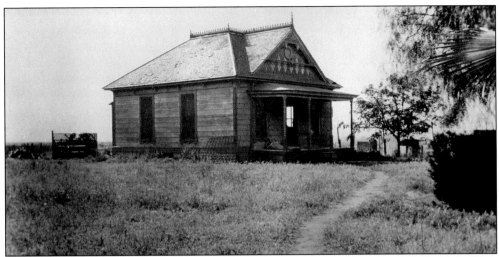

Several ranch homes in the Paularino area were built to this single-story, square, hip-roofed design—some with front gables, some elongated to a rectangular floor plan, some plain, and some dressed up with iron roof ridging and decorative-cut shingles. The Bradbury, Heath, Ferguson, and Mackie ranches all had variants of the basic design. One of these houses survives today and can be seen at 2150 Newport Boulevard. Its architectural features match the house shown above. According to the home's owner, the structure was a stationmaster's house, located at the Paularino siding of the Santa Ana and Newport Railroad, adjacent to a large warehouse used by vegetable farmers in the area. The house was moved to its current location about 1940.

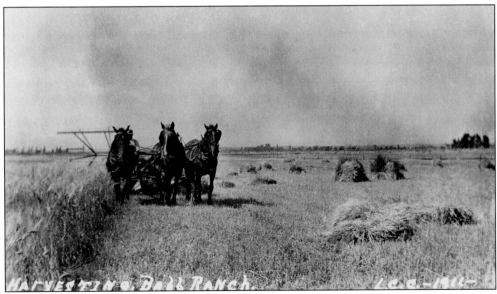

William S. Babb came to Fairview in 1894, having gained ranching skills as a young man in Iowa and Kansas. He raised barley and ran a herd of 65 Jersey cows on 180 acres in Fairview. Later he expanded his operation into Paularino, where he raised barley on the 48-acre field shown above. The field is located north of today's Baker Street, between Fairview Road and Babb Street.

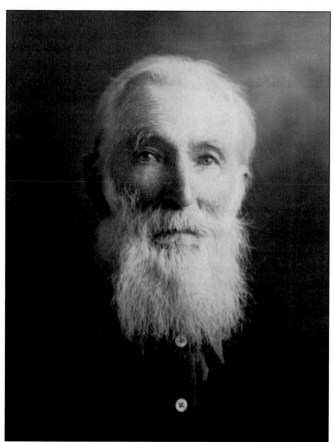

Charles T. Platt came around Cape Horn to El Dorado County, California, from New York in 1854. Before arriving in Paularino in the 1880s, he had mined for gold, worked on a Sacramento River trade boat, bought and lost property in a San Diego land boom, and farmed on the Irvine Ranch. (Courtesy of Keith Hall.)

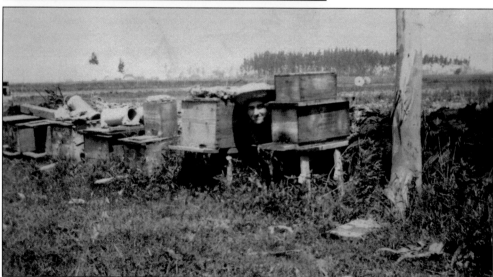

The 53-acre Platt farm extended north and west from the intersection of today's Paularino Avenue and Babb Street, up to the 405 Freeway. Charles's son Lester was born and raised there and worked the farm through the late 1940s. As a teenager, Lester became an accomplished beekeeper—and the farm enjoyed honey. (Courtesy of Jerry Platt.)

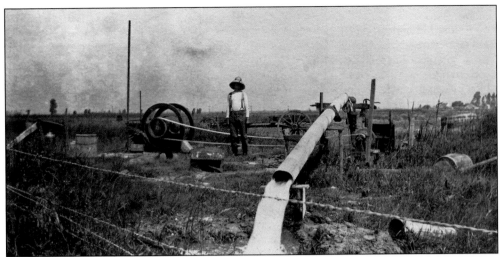

Artesian wells were the primary source of water in the region around Paularino. Charles Platt became a noted well borer, bringing in several wells in the area. As more wells tapped into the aquifer, the water table steadily dropped, necessitating pumping operations such as that shown above. Here Lester Platt is pumping water for irrigation from a second well on the family farm. Later, when the artesian well supplying water to the farmhouse went dry, water was pumped from this well to the house. (Courtesy of Jerry Platt.)

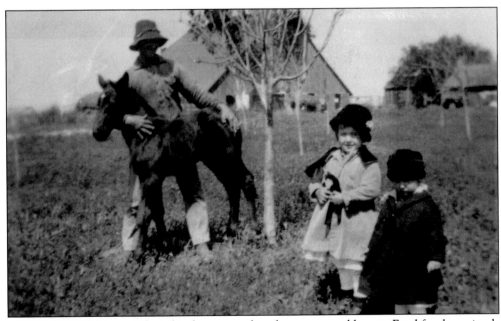

Lester Platt took great pride in his farm animals—dairy cows and horses. Food for the animals was raised on the farm—corn, alfalfa, and oats. Here Lester shows off one of his colts to visiting children. Also visible is the start of an orchard that soon was producing apricots, peaches, oranges, lemons, figs, quinces, pomegranates, plums, and nuts for the family. (Courtesy of Jerry Platt.)

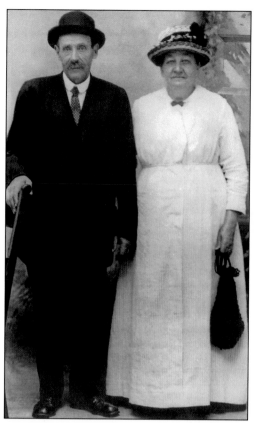

Emigrating from Sweden in 1882, Charles J. (C. J.) and Bertha Segerstrom spent 16 years in the Midwest before coming to Orange County in 1898. First settling on an inland orange grove, they passed through Greenville (then called Old Newport) on a pleasure outing to Newport Beach and were so pleased with the area that they decided to relocate there. Over the years, C. J. Segerstrom and his sons increased their land holdings in the area, engaging in dairying and eventually becoming America's largest independent producer of lima beans.

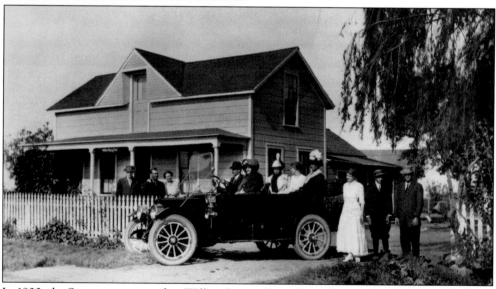

In 1900, the Segerstroms moved to Willow Spring Farm, located on today's Fairview Road near its intersection with Baker Street. In this photograph, C. J. and Bertha Segerstrom are seen in the front seat of their new 1911 Franklin automobile. Segerstrom family members are, from left to right, Anton, William, unidentified, C. J. (at wheel), Bertha, Carrie (wife of Charles Jr.), Ann, Christine, Ida, Harold, and Fred. Charles Segerstrom Jr. probably took the photograph.

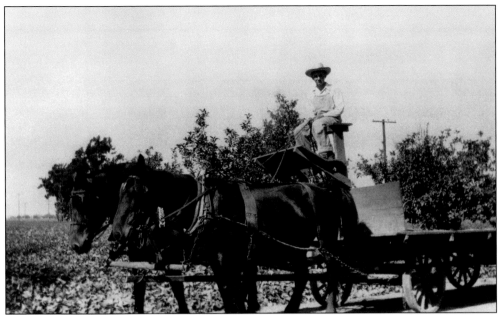

One of the first crops of lima beans was being raised as Charles Segerstrom Jr. (grandson of C. J. Segerstrom) drove this hay wagon on the family's Greenville property around 1917. Also noticeable in this photograph is a new feature on the landscape—the utility pole. Telephone service had already come to the mesa, while electricity was being introduced in the late 1910s.

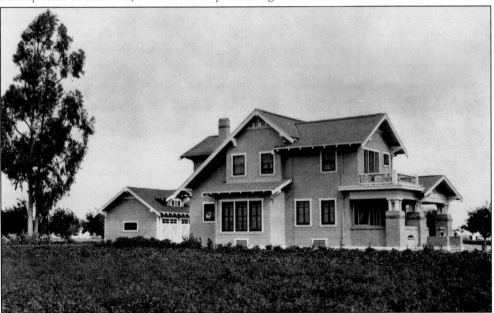

This craftsman-style home was built on the Segerstrom "Home Ranch" property in 1915. The home became the center of a family partnership formed among C. J. Segerstrom and his four sons who remained in the area to operate farms: William, Anton, Fred, and Harold. The family remained very close-knit and followed a policy of "buy and don't sell land." The Segerstroms' decision to stay with their local landholdings, coupled with vision and community spirit, eventually would make Costa Mesa a renowned center for retail sales and performing arts.

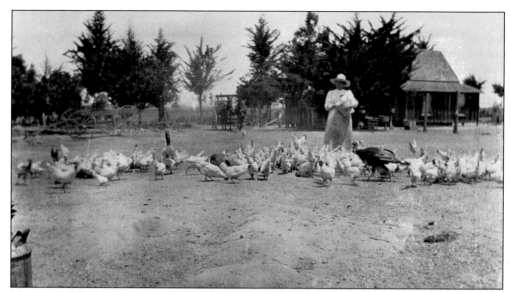

Martin A. Baker (namesake of today's Baker Street) was a Civil War veteran whose family had moved from North Carolina to Kentucky, Iowa, and then Kansas during the prewar period of agitation about slavery. Baker came to Paularino in 1887, and according to Samuel Armor's 1921 *History of Orange County*, Baker had placed his 40-acre ranch "in a high state of cultivation, raising large crops of grain and alfalfa and also winning merited success with all varieties of small fruits." Here Lena M. Baker is feeding her flock on the family ranch on the southwest corner of today's Baker Street and Newport Boulevard.

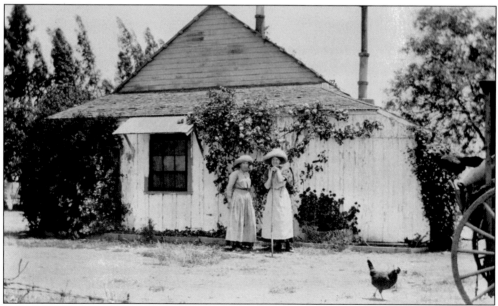

Pictured here is Mrs. Yetter with an unidentified friend at the "Doc" Stevens place located on today's Bristol Street south of Baker Street. Mrs. Yetter took care of Stevens in his later years. According to May Chatterton Hallowell, "In later years, she took in two or three old men to care for. They gave her their life savings to keep them as long as they lived."

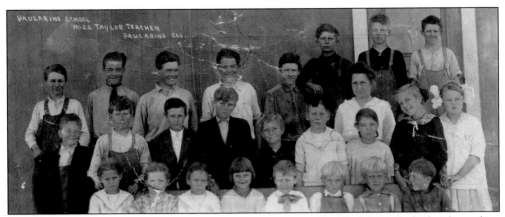

At first, Paularino children attended school at Fairview. Sometime before 1912, the local populace decided to form their own school district and built a one-room schoolhouse at the northwest corner of today's Baker and Bristol Streets. This photograph of the 1916–1917 class shows teacher Mildred Taylor surrounded by 25 students, many bearing settler names such as Jamieson, Baker, Flint, and Shiffer.

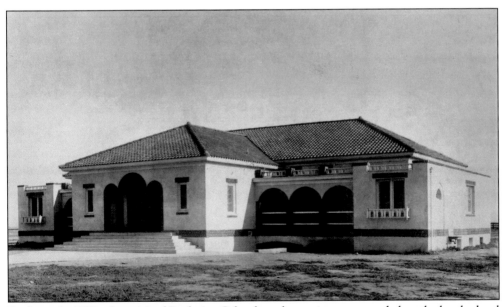

By the early 1920s, the original Paularino School was becoming overcrowded, so the local school district bought land from James Irvine and built this Spanish-style schoolhouse at the northeast corner of Paularino Avenue and Newport Boulevard. The first school term at the new school, 1922–1923, had the highest enrollment to that time with 26 girls and 17 boys. The school was demolished in 1966 to make way for the 55 Freeway.

All of the farms that once made up Paularino have disappeared. The last to go was the Jake Shiffer place in 1973. But a few reminders of the past lasted a bit longer, such as the windmill and water tanks pictured here at the southeast corner of today's Baker and Bristol Streets that stood in witness to annexation and city development through the late 1970s.

Four

EARLY COMMUNITIES
HARPER

A siding of the Santa Ana
and Newport Railroad
located along today's
Newport Boulevard
between Eighteenth and
Nineteenth Streets formed
the hub of the third early
community in Costa Mesa,
the village of Harper. With
transportation available,
large-scale grain farmers
worked the area and
provided an economic
base. Gregory Harper
(pictured here) and Will
Harper were brothers who
leased acreage on the
Banning property south of
Nineteenth Street and west
of Newport Boulevard. The
railroad siding was named
Harper, a name that stuck
even after the Harpers
moved away in 1903.

Beginning in 1898, Henry D. Meyer began farming 3,000 acres of the Banning tract that he leased on a long-term basis. (See photograph on pages 18 and 19.) His crops were hauled to a warehouse he had built at the Thurin railroad siding, located along today's Newport Boulevard at Twenty-third Street. The Meyer family farmed the area until 1930, occupying the wood-frame portion of the Polloreno Adobe until 1903, when they purchased, moved, and occupied the old Im Hof house, shown at the top of page 20.

One of Henry Meyer's threshing crews takes a lunch break on the mesa while draft horses gather around a feeder wagon. According to Henry's son, Irving Meyer, "Many horses and mules were required to operate this place. During the dry years many people couldn't get enough hay to feed their horses. They used to turn them out to pasture."

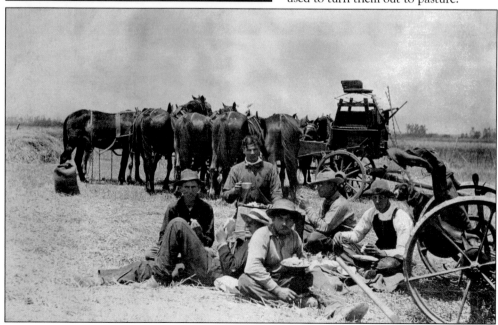

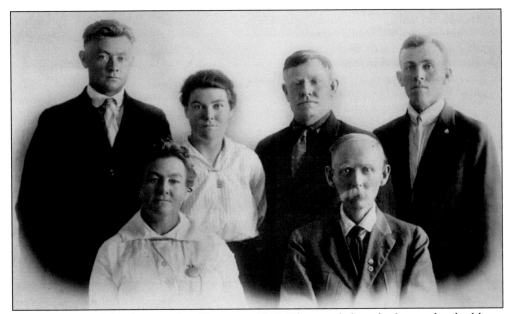

The Robert Boyd family moved to Harper in 1903. They settled in the house that had been occupied by the Harpers and farmed land leased from the Bannings. At the time the Boyds moved here, they were one of only a few families living in the Harper area. From left to right are (first row) Mrs. Boyd and Robert Boyd; (second row) John Boyd, Nellie Boyd, Harry Boyd, and William Boyd.

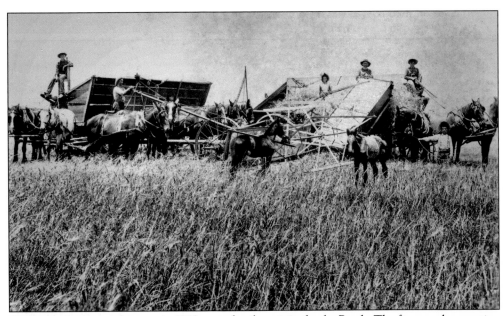

Harvesting barley on the mesa in 1903 was a family activity for the Boyds. The five people operating the equipment are Robert Boyd and his four children (see family portrait above). A hired hand at the right tends one of the horses.

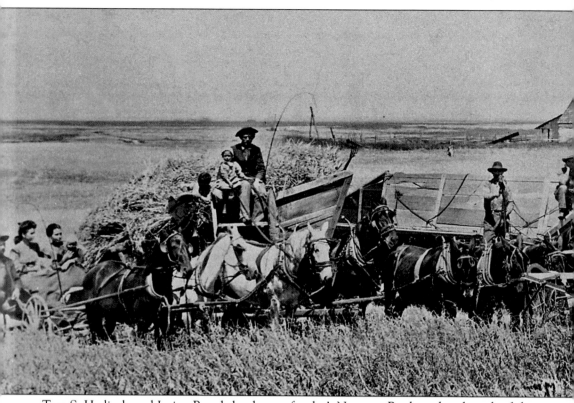

Tom S. Harlin leased Irvine Ranch land east of today's Newport Boulevard and south of the 73 Freeway, farming the area from 1897 to the late 1920s. The view above shows the Harlins harvesting grain in 1906 with help from relatives and neighbors with the names Devenney, Rogers,

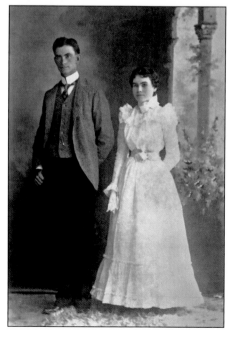

Tom S. and Sadie Devenney Harlin were married in 1899. Tom was a native Californian, born and raised in the Santa Ana area. His father, T. J. Harlin, ran a general store located at Sycamore and Fourth Streets in Santa Ana.

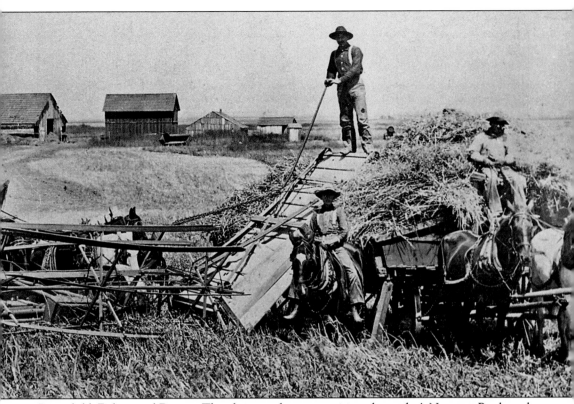

Pesterfield, Fickus, and Duarte. The photographer was positioned at today's Newport Boulevard looking east toward what would become the Santa Ana Country Club.

One of only three families living on the east side of Newport Boulevard in the Harper area, the Tom Harlins lived in a house where the Santa Ana Country Club is located today. Tom and Sadie Harlin (rear row, right) had five children, three of whom are shown here along with several members of the Devenney and other families.

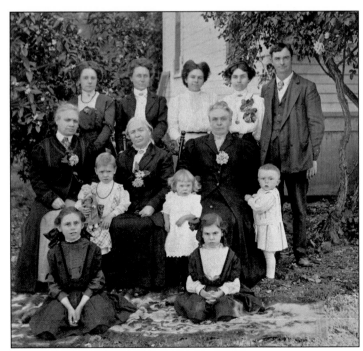

In spite of several dry years after 1897, large-scale grain farming by a half-dozen ranching families became established in the Harper area. By 1906, the status quo was about to change. In that year, the Townsend-Dayman Investment Company brokered a deal with the Irvine Company to acquire 1,700 acres of grain farmland. That parcel was named the Newport Heights subdivision, located as shown on page 2. The developer subdivided the parcel into 5-acre tracts and, of paramount importance, established the Newport Heights Irrigation Company. The December 1907 *Santa Ana Register* newspaper advertisement shown here targeted people of modest means—"YOU! Five Acres."

The impetus behind the Newport Heights deal was Stephen Townsend, a university-educated Midwesterner who, after arriving in Southern California, built his management and executive skills to become a bank official and a partner in several land investment companies. Within a year after placing the 5-acre lots on the market, more than 200 had been sold. In April 1907, Stephen Townsend filed a tract map for a new subdivision, Newport Mesa, situated west of Newport Boulevard.

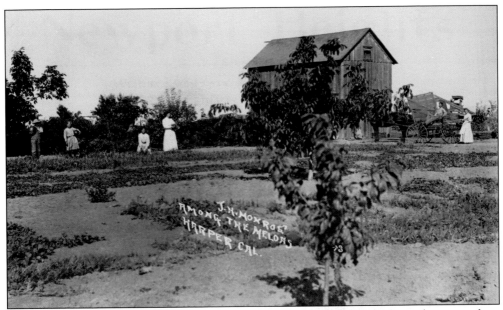

The availability of 5-acre lots and irrigation water would create lasting change on the mesa—from large-scale grain farming to small-scale family farming. Among the early families to settle in the Newport Mesa Tract were the John H. Monroes from Wayne County, Michigan, via Long Beach. In April 1907, the Monroes moved to acreage on the east side of Orange Avenue, between East Eighteenth and East Nineteenth Streets. Within a couple of years, they had built a house and small barn and had produced a fine crop of watermelons—the era of small-scale fruit and vegetable farming had begun.

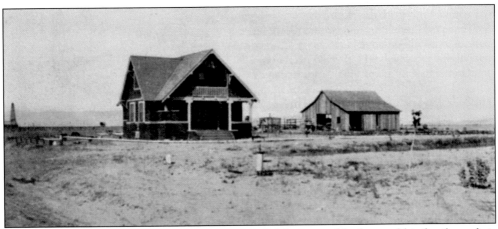

Edward H. Ashley had sold his place in Orange, California, and had moved his family to their summer home in Seal Beach, where he met an agent for the Newport Heights Tract, Mr. Van de Water. Subsequently he purchased 15 acres in Newport Heights, located on the northeast corner of Orange Avenue and East Twenty-second Street. Evident in this 1908 photograph are the Ashley home, barn, water piping, streets, and, in the distance at the left edge, the oil derrick at Well No. 1 (see page 56). The Ashley house still stands today—the oil derrick does not.

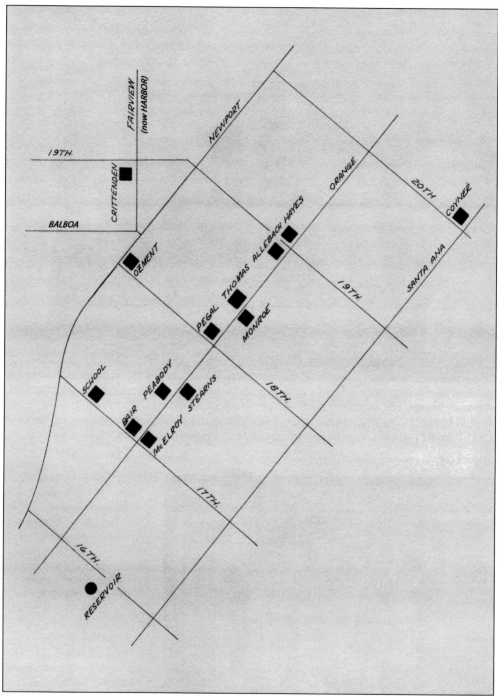

By the end of 1908, most of Harper's settlers were located between Newport Boulevard, Orange Avenue, East Seventeenth and East Nineteenth Streets. The nucleus of modern Costa Mesa had formed on what had been grain-farming land just three years prior.

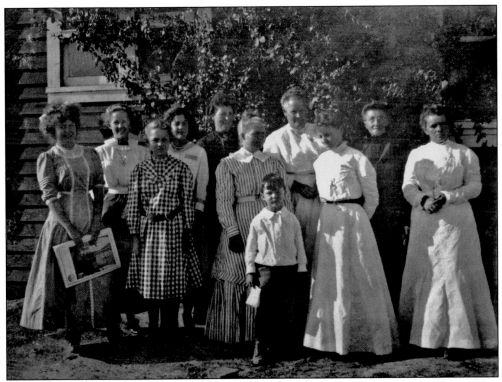

This gathering of Harper women in 1910 may be seen as a precursor to what would become a Costa Mesa institution, the Friday Afternoon Club. The women's club would become more than a social group—it would undertake community improvement projects as well. Pictured from left to right are Rose Ashley, Sylvia Crittenden, Marion Crittenden, Irene Ashley, ? Hayes, ? Holt, ? Ashley (child), ? Crittenden, ? Ashley, ? Thomas, and ? Stearns.

There was a bit of confusion leading up to the establishment of Harper's first public school. After a committee of the townsfolk visited the tract's developer, Stephen Townsend, and showed him a clause in the land contract that guaranteed a school for local children by the fall of 1908, Townsend hired a teacher and arranged for the farmhouse shown here to be remodeled. It became known as the "little green schoolhouse." Pupils in the photograph include family names of Monroe, Ozment, Bair, Boyd, and Holt.

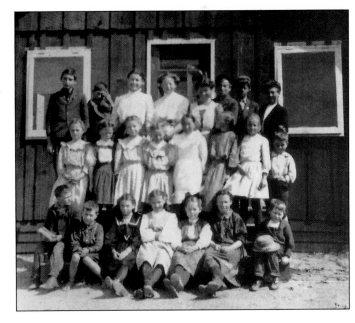

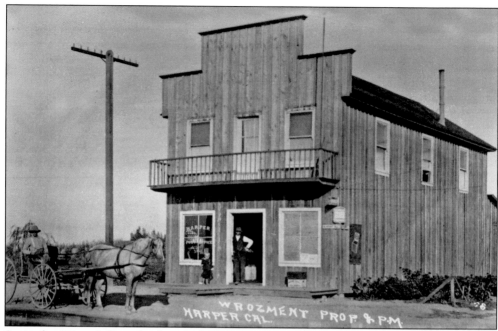

Soon after Harper's first school opened, Walter R. Ozment built the first commercial building in town, a two-story board-and-batten structure with a general store downstairs and living quarters upstairs. According to Mabel Ozment Fuller, "Groceries were on one side and yardage on the other. And there were three wall lamps on each side of the building." The store was located on the northeast corner of Newport Boulevard and East Eighteenth Street.

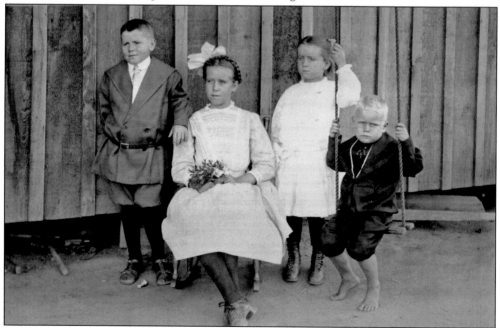

Walter R. Ozment was a grocer in Greensboro, North Carolina, before arriving in Harper with his family in 1908. The family moved to Southern California because of his daughter Mabel's asthma. Pictured here are the four Ozment children, from left to right, Starr, Mabel, Grace, and Paul.

The local citizens decided they wanted a post office in town and were informed by the postmaster general that the district required a name before a post office could be authorized. A meeting was held, and it was decided to keep the name of the railroad siding that had been in use for more than 10 years—Harper. Walter Ozment was duly appointed postmaster on March 25, 1909. His wife, Velma Ozment, was named assistant postmaster.

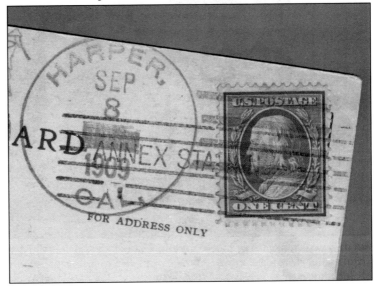

The postcard pictured here was postmarked St. Louis, Missouri, on September 4, 1909, and shows a receiving postmark at Harper of September 8. The postcard was addressed to "Master Starr Ozment, Harper, Orange County, Cal."

Within two years, enrollment at the Harper School outgrew the little green schoolhouse. Stephen Townsend donated property on the southeast corner of East Seventeenth Street and Orange Avenue for a new schoolhouse. In September 1910, the two-room school received its first class, with teacher Beatrix Miller in charge of 34 pupils.

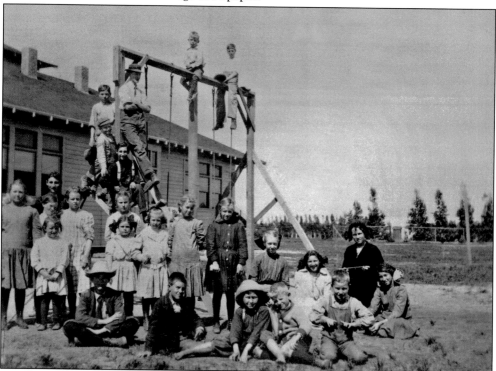

The first entering class at Harper's new school in the fall of 1910 included children from the Rochester, Lorton, Deffley, White, Beswick, Bair, McElroy, Ozment, Sherwood, Cleghorn, Monroe, and Savage families.

Brisk sales of 5-acre lots in Newport Heights encouraged other developers to enter the fray. In 1912, the Bryan and Bradford Company purchased 1,000 acres from the Banning family, developed a viable water system, and began selling 10-acre lots in the Fairview Farms tract. The tract was located north of Newport Heights. Some of the first settlers in the new tract were J. R. Smith and family, shown here standing behind the Harper School. The Smiths grew lemons and grapefruit on their 10-acre spread.

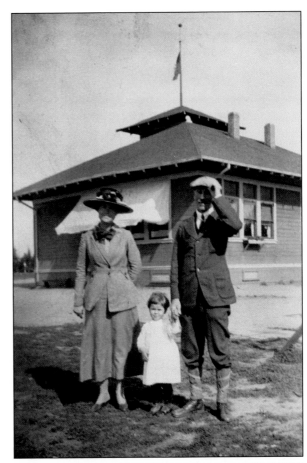

In the spring of 1911, visiting clergy conducted the first church services in town; a year later, on Easter Sunday 1912, the Harper Methodist Episcopal Church held its first services in the Harper schoolhouse. In the fall of 1914, Stephen Townsend donated land on the southwest corner of Balboa Street and Newport Boulevard for the congregation to build a permanent church. Dedication services were held at the new church, below, in March 1915.

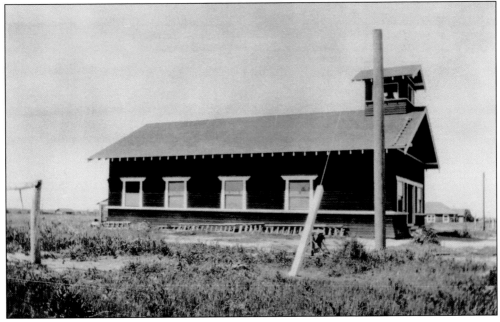

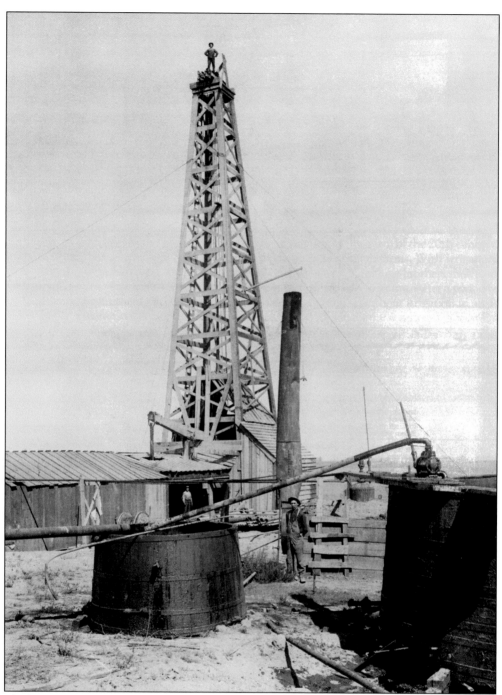

The latter part of 1907 saw the drilling of several oil wells at the northeastern end of the Newport Heights tract. The operation shown here, simply named Well No. 1, was located near the intersection of Twenty-second Street and Irvine Avenue. The oil was so thick it was difficult to pump, so the Harper oil boom faded within a few years. More than 40 years later, however, the threat of "oil blight" would become one of the rallying points for incorporation of the City of Costa Mesa.

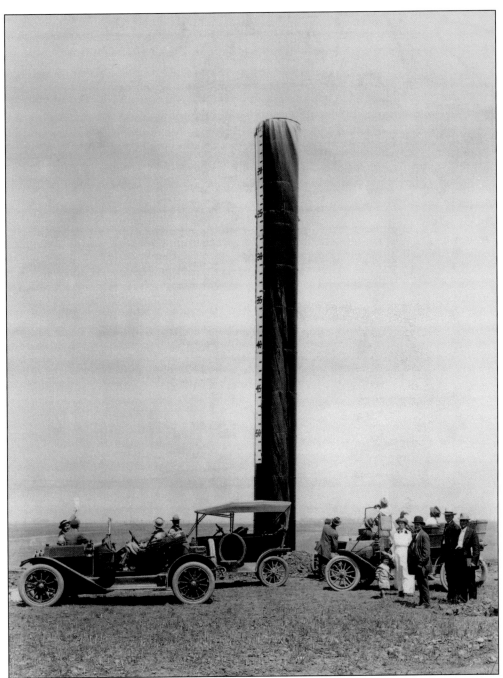

To their credit, the Fairview Farms developers recognized the importance of a reliable supply of water and took action to build an adequate system. Consisting of wells, pumps, standpipe, reservoir, and distribution piping, the Fairview Farms Mutual Water Company, Inc., issued stock to landowners—one share per acre of land. This 1913 photograph shows the company's standpipe measuring 5 feet in diameter and 56 feet tall. It was located in line with Hamilton Street, at the edge of the bluff overlooking the Santa Ana River, with the pumping station due west on the river flatlands.

Although dry farming was the norm for grain and bean farming at the dawn of the 20th century, irrigation, and thus a water supply, was essential to the success of small farms. With irrigation, fruit orchards, vegetable crops, and poultry raising became popular. The three brothers shown on their ranch at West Nineteenth Street and Monrovia Avenue tried dry farming. After a period of scant rainfall, the brothers' operation folded. (Dry farming is farming without irrigation in areas of less than 20 inches of average annual rainfall.)

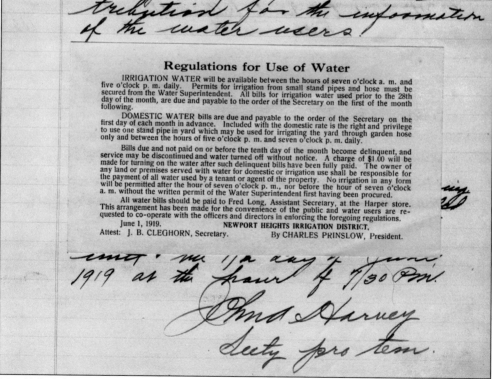

Regulations for Use of Water

IRRIGATION WATER will be available between the hours of seven o'clock a. m. and five o'clock p. m. daily. Permits for irrigation from small stand pipes and hose must be secured from the Water Superintendent. All bills for irrigation water used prior to the 28th day of the month, are due and payable to the order of the Secretary on the first of the month following.

DOMESTIC WATER bills are due and payable to the order of the Secretary on the first day of each month in advance. Included with the domestic rate is the right and privilege to use one stand pipe in yard which may be used for irrigating the yard through garden hose only and between the hours of five o'clock p. m. and seven o'clock p. m. daily.

Bills due and not paid on or before the tenth day of the month become delinquent, and service may be discontinued and water turned off without notice. A charge of $1.00 will be made for turning on the water after such delinquent bills have been fully paid. The owner of any land or premises served with water for domestic or irrigation use shall be responsible for the payment of all water used by a tenant or agent of the property. No irrigation in any form will be permitted after the hour of seven o'clock p. m., nor before the hour of seven o'clock a. m. without the written permit of the Water Superintendent first having been procured.

All water bills should be paid to Fred Long, Assistant Secretary, at the Harper store. This arrangement has been made for the convenience of the public and water users are requested to co-operate with the officers and directors in enforcing the foregoing regulations.

June 1, 1919. NEWPORT HEIGHTS IRRIGATION DISTRICT,
Attest: J. B. CLEGHORN, Secretary. By CHARLES PRINSLOW, President.

Mindful of the importance of water, Newport Heights landowners formed the Newport Heights Irrigation District to take over and improve the original water system built by the tract's developers. This copy of the district's water regulations was pasted onto the handwritten minutes of a June 1919 board meeting. Water users were well advised to observe the watering times and pay their bills promptly!

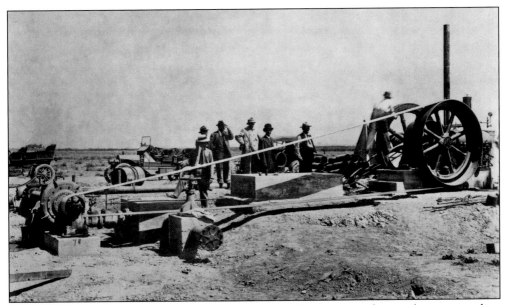

The Fairview Farms pumping plant shown here pumped water up to the standpipe pictured on page 57. The wells and pumps were located on the lowlands on the east side of the Santa Ana River. A river levee can be seen on the horizon.

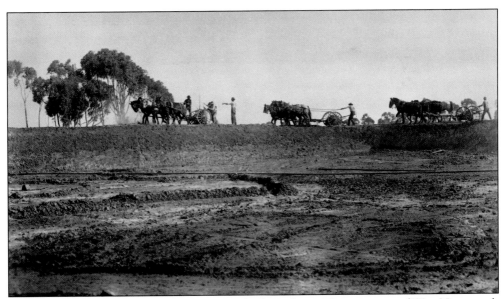

In 1913, this 1.25-million-gallon reservoir was built on the northwest corner of West Nineteenth Street and Placentia Avenue. The Fairview Farms and Newport Heights water systems were the most important factors in the viability of the Harper area as compared to the by then defunct town of Fairview just 2 miles north.

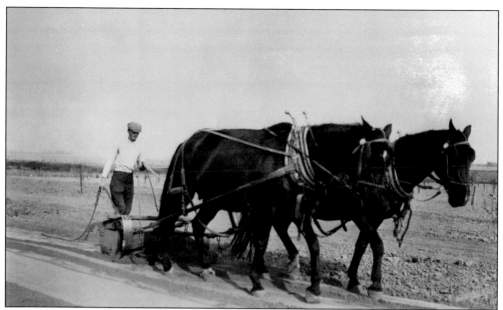

In 1912, Howard B. Woodrough purchased six lots for a total of 30 acres in the Newport Heights tract. Shown here preparing the land, he planted apple trees and ran a successful orchard operation. According to Woodrough, "The soil is excellent for working and water conditions good."

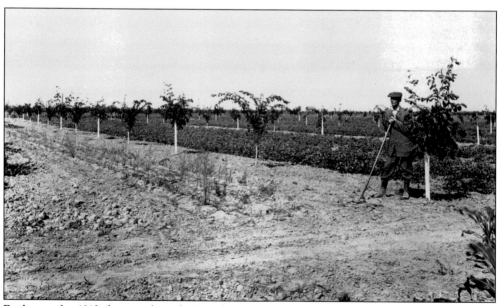

Evident in this 1913 photograph on the Woodrough farm is the practice of "alley cropping"—planting field crops in the rows between the relatively wide-spaced fruit trees. One can speculate about the message in Howard Woodrough's pose—perhaps the attainment of success as a gentleman farmer? Also barely visible on the horizon to left of center is an oil derrick, probably at Well No. 1.

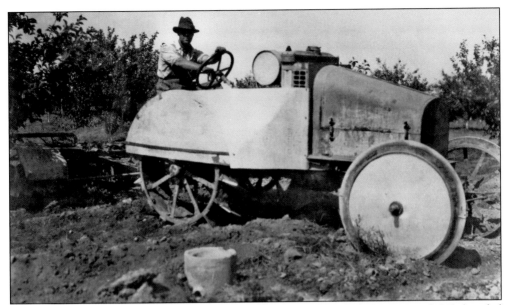

George Waterman moved to the Newport Heights area in 1909 and, in the spring of 1910, founded a nursery for apple trees. He and another farmer each planted 5 acres of trees, thus establishing the first commercial orchards in the area. Apples were later to play a major role in the growth of Harper. The photograph above, taken in 1920, shows Waterman working his orchard on his International Junior 8-16 kerosene tractor.

By 1920, apples had become a major crop in Harper, with lemons in second place. Peaches, plums, and pears were favorites in home gardens. Harper apples proved to be of exceptionally fine flavor and were in great demand throughout Orange County. At first, growers sold their fruit directly to the public at their orchards. Later they would form a grower's association and build a packinghouse. This 1920 photograph shows mature trees in the Donald Dodge orchard.

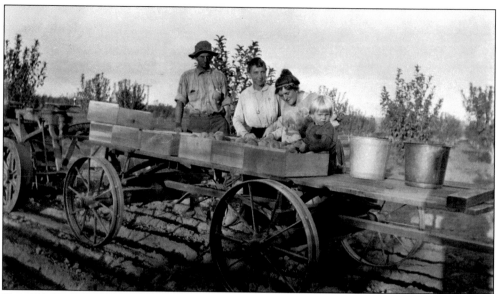

Donald J. Dodge came to Southern California in 1911 seeking relief from the severe summertime hay fever he experienced in the Midwest. He was a city boy and had never known any type of farm work. According to Dodge, "I came out here from St. Louis and began to grow apples 'according to the book,' much to the amusement of some of my neighbors, for at that time apples were an unheard of crop in this section." Shown here around 1915 are, from left to right, Donald J. Dodge, unidentified, Frances Taylor Dodge, Donald Dodge Jr., and Betty Dodge.

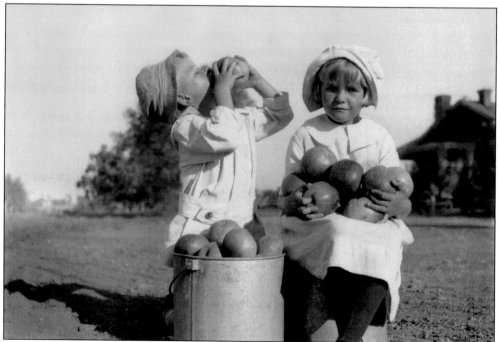

Long before the city of New York appropriated the slogan, Donald Dodge Jr. takes a bite of the big apple right here in Harper, California. The two Dodge children reflect the youthfulness of the community on a bountiful land that yielded the highest quality crops.

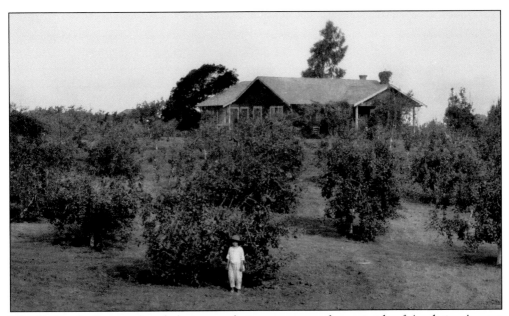

The Dodges built a ranch-style house on their property on the west side of Anaheim Avenue between Eighteenth and Nineteenth Streets. In this photograph, Betty Dodge invites the viewer to take a closer look at her family's orchard and home.

Donald Dodge's apples won Orange County Fair blue ribbons over several years and were in demand throughout the region. According to Dodge, "I regard the mesa grown apples as of highest quality and the best flavored in California." Donald Dodge went on to become a judge and civic leader in Costa Mesa.

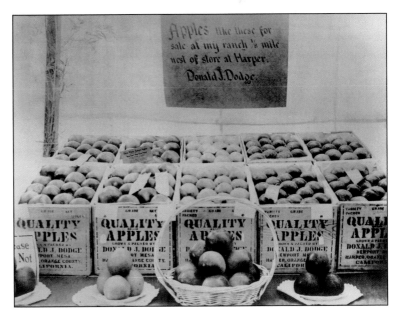

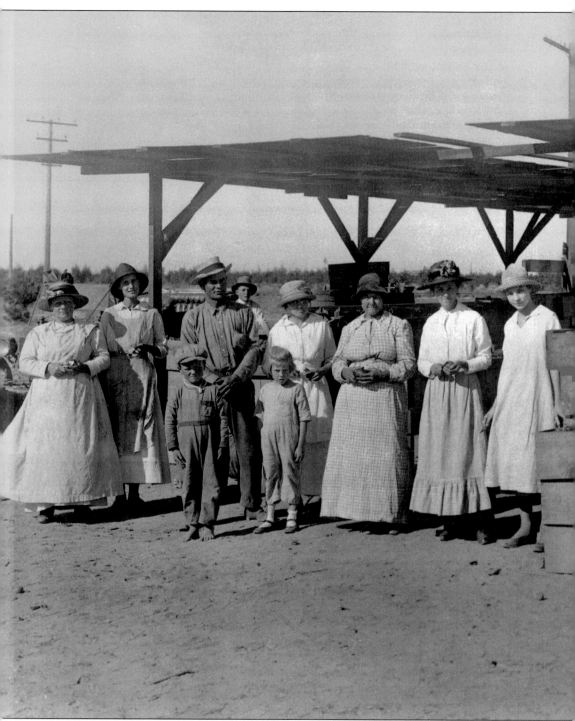

Heading into the Roaring Twenties, Harper had become an established and growing community, still rural but poised for increased commercial and residential growth. Contributing to the permanence of the place were tract development and promotion, sustainable water supply, nascent civic leadership, new road construction, and high-quality, diversified farm output. One

retail outlet for local crops was Logsdon's Fruit and Vegetable Stand, pictured above in 1919 at the southeast corner of East Twenty-first Street and Newport Boulevard. In December 1919, Ed Logsdon shipped the first carload of apples from Harper. In total, he sold more than 90 tons of apples and 1,000 gallons of cider that year.

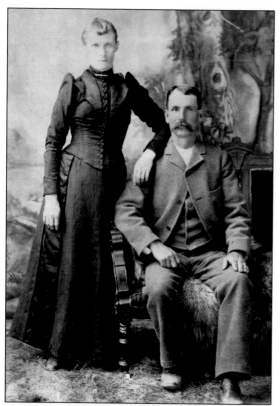

James S. and Elizabeth Ellis came to the Santa Ana area from Tennessee via Los Angeles in 1886. In 1900, he leased 3,100 acres from the Irvine Company and turned the acreage over to his 15-year-old son, Boyd. They planted the acreage in barley and established a home near the intersection of Irvine Avenue and East Twenty-second Street. The grain threshing operation of Boyd's brother Henley is pictured on page 28.

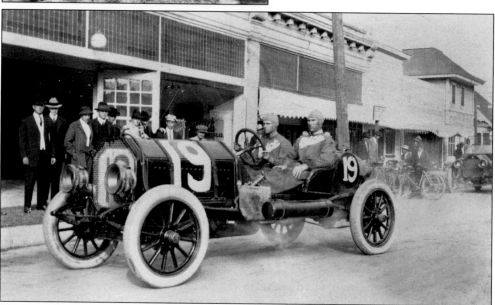

The two Ellis brothers, Henley (left) and Boyd, entered their 1909 Buick in the 1913 Los Angeles–to–Phoenix Road Race, also known as "The Cactus Derby." Following roughly the path of the future Route 66, they finished out of the money in seventh place, after stopping to assist another racer who had overturned near Yuma. The following year, they finished sixth behind Barney Oldfield. Nevertheless, their exploits brought Costa Mesa into the automobile age with a flourish.

The Ellis ranch was located on the east side of Irvine Avenue, near the intersection with East Twenty-second Street. Boyd Ellis built the home; his mother, Sarah Ellis, and sister Carrie lived there for many years. Boyd moved after 1905 when the Irvine Company sold land to Stephen Townsend for the Newport Heights tract, and there was no longer enough land in the immediate area for grain farming.

The Walter W. Middleton family came to Harper in 1914, settling on 10 acres in the Fairview Farms tract west of Harbor Boulevard and south of Wilson Street. Clara Middleton, pictured here, was active in the Friday Afternoon Club, a women's group that not only brought the area women together but also undertook community improvement projects. Walter Middleton pioneered in raising apples in the area, operated the first school bus in the Fairview-Harper district, joined the board of the Fairview Farms Mutual Water Company, Inc., and served as postmaster from 1925 to 1934.

Pictured below at the Middleton home on Wilson Street are the Middletons' daughter Nina Mae Middleton (right) and her cousin William Salisbury, dressed for Sunday school.

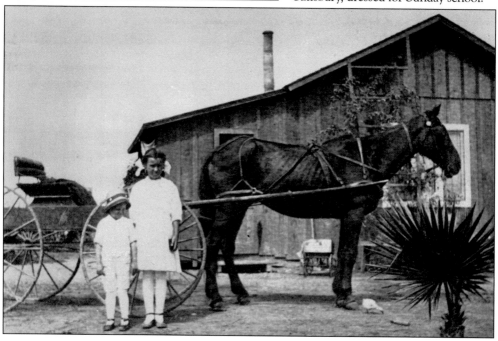

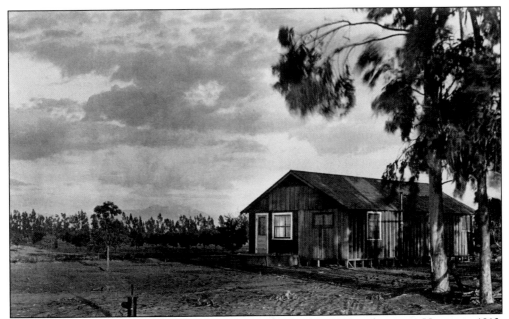

The George H. Hempshall family emigrated from England in 1912 and came to Harper in 1913. Hempshall worked on the Dodge and Woodrough farms, took care of the Palisades Tavern, ran the Newport Heights water pumping plant, and managed acreage for Stephen Townsend. In this 1920 view of the Hempshall home, located on the northeast corner of East Nineteenth Street and Tustin Avenue, Old Saddleback Mountain is clearly visible in the distance.

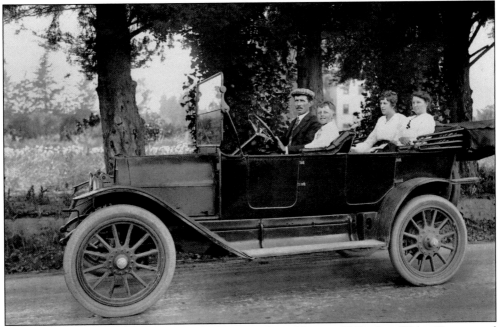

The number of automobiles in the area had increased steadily since 1910, when Walter Ozment and Henley Ellis became the first "horseless carriage" owners in town. About 1917, the Hempshalls bought the 1913 Oakland automobile shown here. Enjoying the ride in their soft-top touring car are, from left to right, George H. Hempshall, Horace Hempshall, unidentified, and Edna Hempshall.

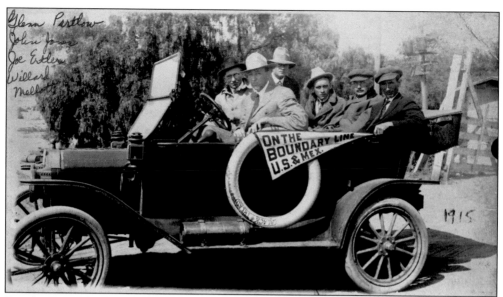

Development of tracts featuring 5- to 10-acre lots meant dozens of streets had to be surveyed and graded to provide each landowner access to his property. Willard Mellott was contracted to grade streets in the Fairview Farms tract. Mellott hired Ed Bennett to help. In this photograph dated 1915, Ed Bennett (behind the wheel), Will Mellott (extreme right), and friends are headed for an outing in San Diego in their 1913 "Tin Lizzie."

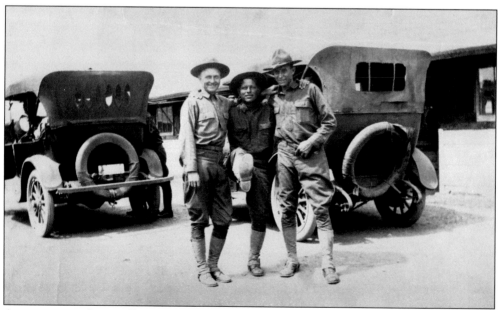

As in so many other small communities, Harper residents felt the personal impact of the United States entry into World War I, as its fine young men went off to fight in the "war to end all wars." Ed Bennett, John Boyd, Bill St. Clair, Johnny Jones, Bill Rochester, and Bill's brother Nat Rochester were among those to go. Pictured here at Camp Kearny in San Diego County are, from left to right, Ed Bennett, Pat Bear, and Ray Lauffenburger.

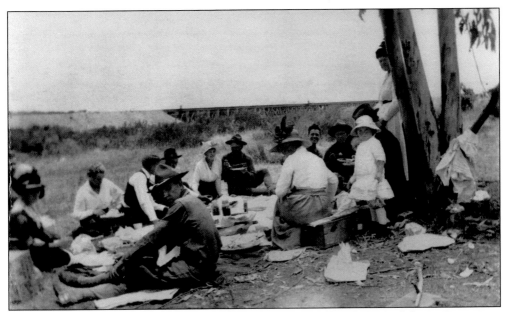

Family and friends visited the troops near Camp Kearny (San Diego County) for a picnic outing before the boys shipped off to war. Included in the scene, in no particular order, are Mr. and Mrs. Ogden, Ogden children, Mr. and Mrs. Boyd, Pat Bear, Nat Rochester, Ed Bennett, Mr. and Mrs. John Jones, Clarence Prinslow, Minnie Prinslow, John Boyd, Mrs. King, and Ray Lauffenburger.

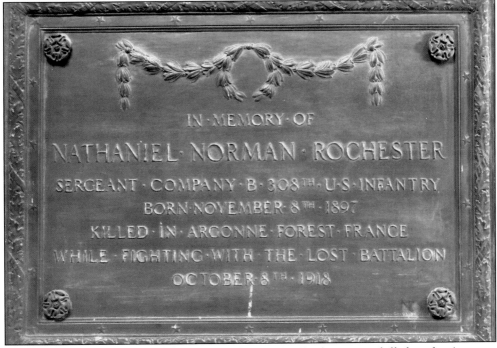

One of Harper's young men did not return home. Nat Rochester was killed in the Argonne Forest of France fighting with the famed "Lost Battalion," just one month before the armistice was signed ending World War I. Rochester Street was named in Nat's memory, and the bronze memorial plaque pictured here was placed in the Costa Mesa Grammar School.

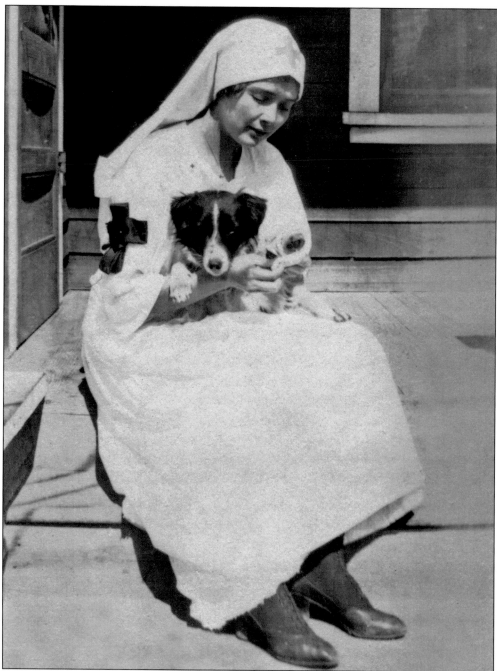

On the Harper home front, there was a shortage of nurses at the Santa Ana Hospital, so Alice King signed up to serve as an aide. She assembled a uniform and practiced her bandaging skills on the family dog, as pictured above. Best intentions notwithstanding, Alice contracted a case of the Spanish flu during a worldwide influenza epidemic that lasted from March 1918 to June 1920. According to Alice King Eastman's 1978 oral history interview, the remedy prescribed by her doctor, Mrs. A. E. Block, was an elixir high in alcohol content. She took two tablespoons every two hours and felt better almost immediately.

Five

WHAT'S IN A NAME?

Although mix-ups in freight shipments with nearby Harperville served as a catalyst, local citizens wanted a more appealing name for the growing community that now included much more than the original railroad siding and core village of Harper. A contest was conducted to rename the area, and entries were received from as far away as Florida. Pictured above with her father is Alice Plumer (left), whose entry, "Costa Mesa," won the $25 prize. Her entry, which translates to "coastal tableland" in English, recognized both the area's Spanish heritage and its main geographical feature.

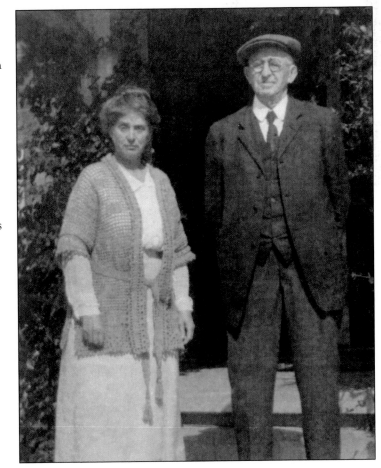

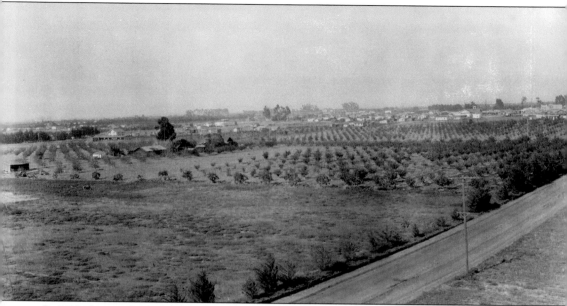

By 1923, the population of Costa Mesa was approaching 2,000 people. In this two-panel panoramic view looking east from Pomona Avenue, West Eighteenth Street runs diagonally from bottom left to center, while Anaheim Avenue branches off to the right of center. Visible are the Donald Dodge orchard to the left and the "downtown" area in the distance at the center. To the right of center

Charles W. TeWinkle (left) and Julia "Goldie" TeWinkle came to Harper in January 1920, just four months before the town changed its name to Costa Mesa. The TeWinkles owned the General Store for two years, then sold it and opened TeWinkle's Hardware Store. In 1922, Charles became active in civic affairs through the chamber of commerce, of which he was a founding director. After 30 years of civic leadership, Charles TeWinkle was elected Costa Mesa's first mayor upon the city's incorporation in 1953. Equally civic-minded, Goldie TeWinkle was active in Costa Mesa's chamber of commerce, Women's Club, Boys and Girls Club, and the historical society.

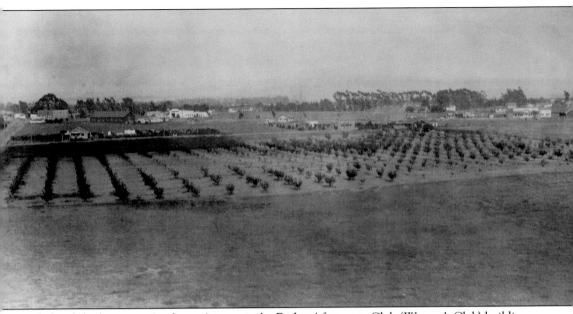

behind the house on Anaheim Avenue is the Friday Afternoon Club (Women's Club) building, still standing today at 1785 Newport Boulevard. To make this photograph, the photographer may have climbed the oil derrick at Jergins No. 1 well, located at the southeast corner of Pomona Avenue and West Eighteenth Street.

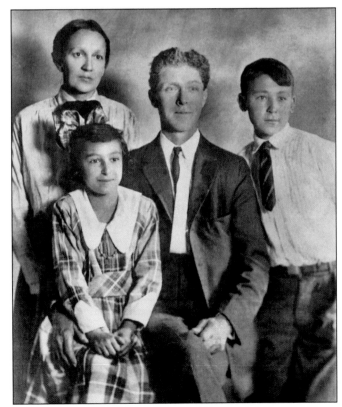

Two more pillars of the community who helped to shape and strengthen young Costa Mesa were W. Carl Spencer (center) and Fanny Bixby Spencer (left rear), shown here with two of their foster children. The Spencers donated land for the Friday Afternoon Clubhouse, provided a rent-free building and several thousand books for a library, started the Boys Club, and beautified the area by planting California poppies along the railroad tracks running parallel to Newport Boulevard.

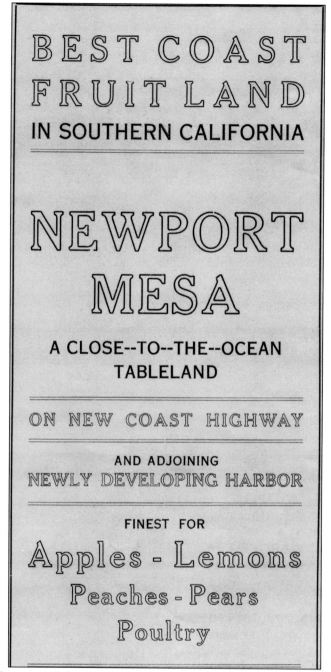

BEST COAST FRUIT LAND

IN SOUTHERN CALIFORNIA

NEWPORT MESA

A CLOSE--TO--THE--OCEAN TABLELAND

ON NEW COAST HIGHWAY

AND ADJOINING NEWLY DEVELOPING HARBOR

FINEST FOR

Apples - Lemons
Peaches - Pears
Poultry

Although development of the downtown commercial district was dramatic, it was still the opportunity of owning a small, productive farm that attracted new settlers. Promotion of the area continued through sales brochures such as that shown here. The September 20, 1921, edition of the *Santa Ana Register* carried this headline: "Apple Harvest Lures Many to Costa Mesa." The news article continued, "This year apple orchards at Costa Mesa not only have added to their pristine reputation for flavor but also have presented their owners with crops that fairly stagger the imagination. Twenty boxes to the tree!"

76

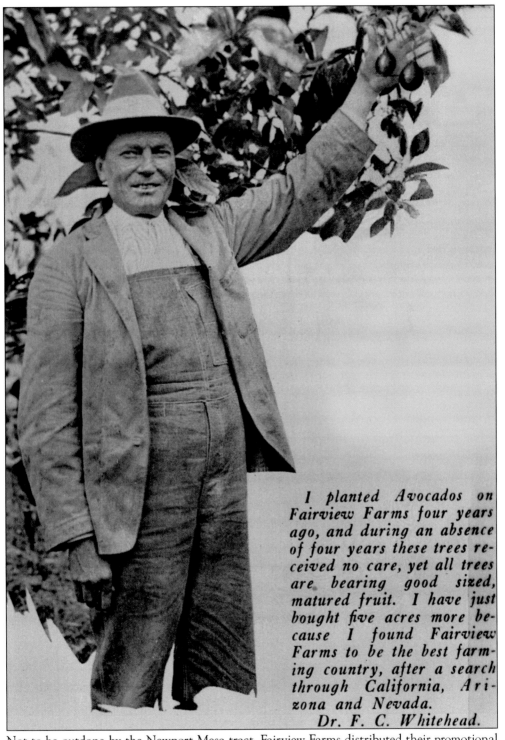

I planted Avocados on Fairview Farms four years ago, and during an absence of four years these trees received no care, yet all trees are bearing good sized, matured fruit. I have just bought five acres more because I found Fairview Farms to be the best farming country, after a search through California, Arizona and Nevada.

Dr. F. C. Whitehead.

Not to be outdone by the Newport Mesa tract, Fairview Farms distributed their promotional brochure in 1921. Shown here is the unabashed testimonial of Dr. F. C. Whitehead, who claimed Fairview Farms offered the best farming country anywhere in Arizona, Nevada, or California.

The second store to open in downtown Costa Mesa was the Wayside Market, built in 1920 on the east side of Newport Boulevard, north of the general store. Electricity arrived in the area soon thereafter with a headline in the January 21, 1921, edition of the *Newport News* proclaiming, "Costa Mesans Happy as 'Juice' Arrives." Electricity allowed the Wayside Market to stay open at night—and it was essential for lighting the jack-o'-lanterns in the Halloween scene pictured here.

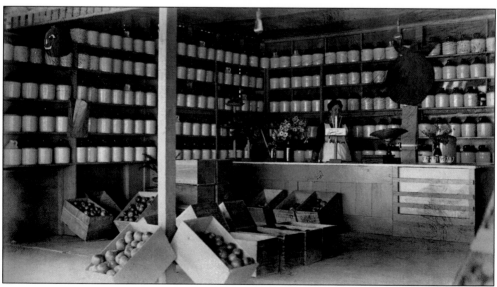

The Wayside Market measured 36 feet wide by 18 feet deep. The facility included a storage room, display racks, service counters, and a section with tables and chairs for serving refreshments, such as locally grown fruit, ice cream, and soft drinks. In this view, nearly 200 cider jugs are lined up along the walls awaiting customers from all over Orange County.

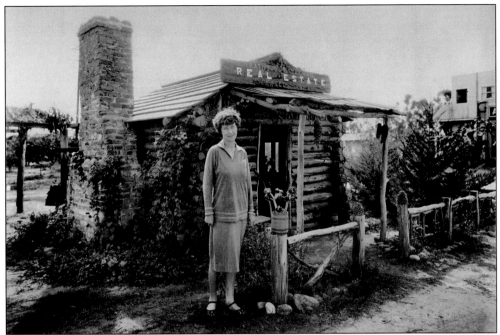

One of Costa Mesa's first businesswomen was Kathryn Mackenzie, a licensed real estate broker whose distinctive office on Newport Boulevard at Cecil Place was known as "The Little Old Log Cabin." In 1926, she was selling lots of up to 10 acres for use as vegetable or fruit farms or as chicken ranches. By then, the price of a 1-acre lot had gone up to $1,400.

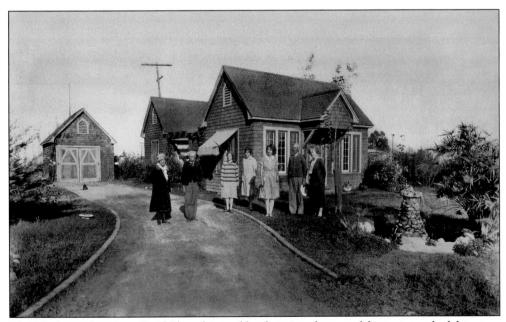

The Mackenzie home on Cecil Place featured landscaping, front yard fountain, curbed driveway, Cape Cod architectural inspiration, and an awning. Kathryn Mackenzie (fifth from left) may have had a hand in designing and building the family home as a local newspaper reported that she was "the only feminine contractor and builder in the west."

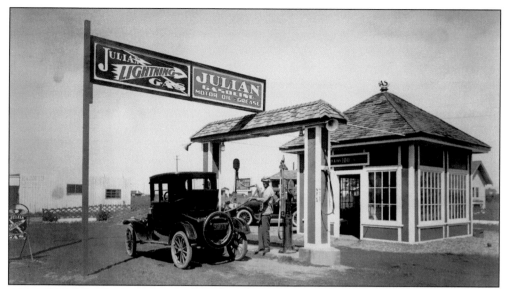

About 1923, Mr. Mackenzie opened a Julian 100 Station at 2248 Newport Boulevard. In this 1925 photograph, Mackenzie is fueling the family's Ford coupe, described as "the little Ford that sold Theo Robbins on Fords." After fueling, a motorist could stop at the building next door to purchase rabbit, live or dressed.

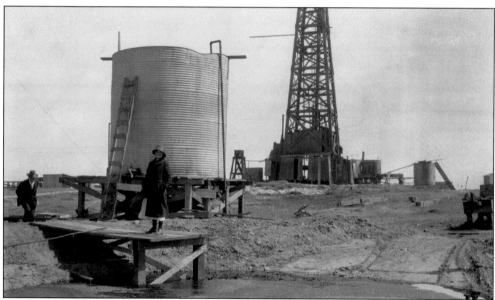

For 40 years after Harper's short-lived oil boom of 1906–1907 (see page 56), drilling for oil was "one of the great outdoor sports of the mesa," according to Judge Donald Dodge—"Always 'good showings' and in a few cases production of oil for a few weeks or months with encroachment of salt water spelling the end." The one exception was in the West Newport Field, west of Whittier Avenue and south of West Nineteenth Street. This 1925 photograph shows Interstate No. 2, located in the Newport Mesa tract, perhaps near the intersection of Placentia Avenue and West Seventeenth Street.

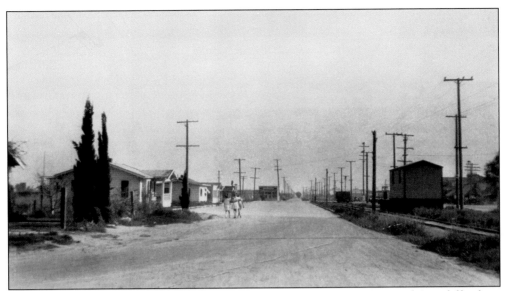

This c. 1924 image of three friends meandering along a deserted street makes it difficult to imagine that Costa Mesa was in the midst of rapid commercial and population growth. The bustling downtown area along Newport Boulevard can be discerned at the extreme right of the photograph, while the railroad platform and a lone gondola car await the next Southern Pacific local train to roll into town.

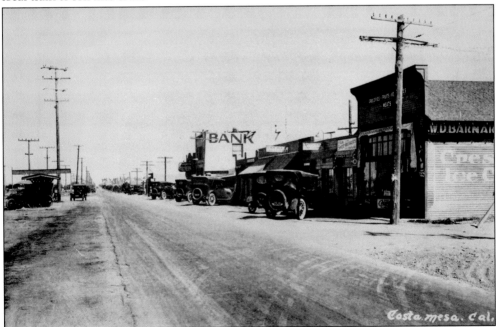

When this photograph of downtown Costa Mesa was taken in 1923, the *Santa Ana Register* had already reported, "Costa Mesa Makes Development Strides: Three years ago Costa Mesa's skyline was virtually nil. It consisted of one store, a garage, and a small real estate office. Today the eye of the camera shows numerous pretentious structures." Pretentious or not, the area was beginning to look like a city, with sidewalks added and a library opened on the second floor of the bank building.

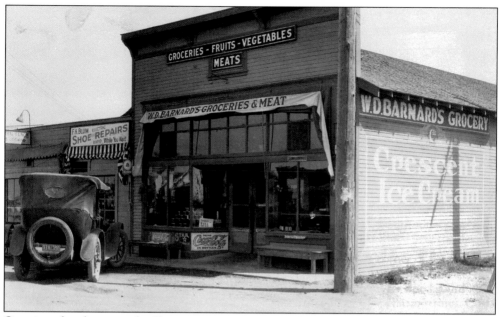

One sign of resilience in the Harper community occurred when the two-story Ozment General Store burned down in 1917. Ozment replaced the store almost immediately with the building shown here. Charles TeWinkle bought the store in 1920 and sold it to W. D. Barnard in 1922. In spite of the fire, it would be several years later before Costa Mesa organized its first volunteer fire department.

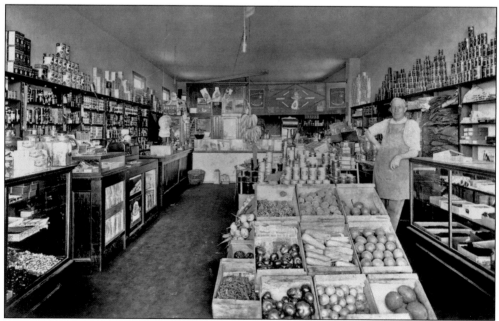

W. D. Barnard's Groceries and Meats featured fresh local produce as well as brand names that are still familiar today: Arm and Hammer, Carnation, Quaker, Calumet, and Life Savers. Friendly service was provided by the store's clerk—the age of self-service had not yet arrived.

In 1925, George Teaney opened his combination feed, seed, and paint store at 126 East Eighteenth Street just off Costa Mesa's main drag. A newspaper advertisement for his Eighteenth Street Feed Store promised all kinds of poultry, dairy, and rabbit feed with prompt delivery at reasonable prices. Teaney was a Boy Scout leader in town.

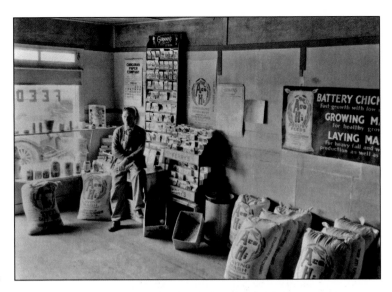

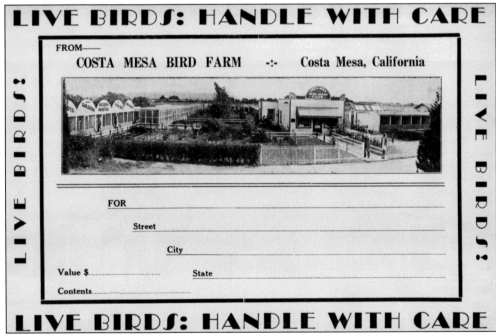

Costa Mesa had its share of unique businesses, such as the Costa Mesa Bird and Game Farm. First opened in 1923 on 2.5 acres near the northeast corner of East Bay Street and Newport Boulevard, M. G. Eighmey and his wife Florence bought the business in 1927. This image of their shipping label tells the story. Just visible on the front walkway is M. G. Eighmey (second from right) showing off one of his prized birds while daughter Virginia looks on. In 1946, Florence Eighmey sold the bird farm as a site for a trailer park.

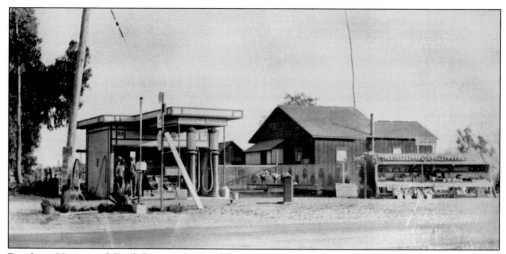

Brothers Harry and Fred Opp opened a filling station at the southeast corner of East Twenty-second Street and Newport Boulevard on Labor Day 1924. On the balance of their acreage, they produced fruit, vegetables, flowers, and gourds. Fred Opp became famous for dried gourd items that included napkin rings, table lamps, magazine racks, and decorative charm strings. Costa Mesa was represented at the 1939–1940 New York World's Fair by an exhibit of Opp gourds. The Opp "gourd place" was sold to Mesa Homes in 1951 to make way for a 29-home tract.

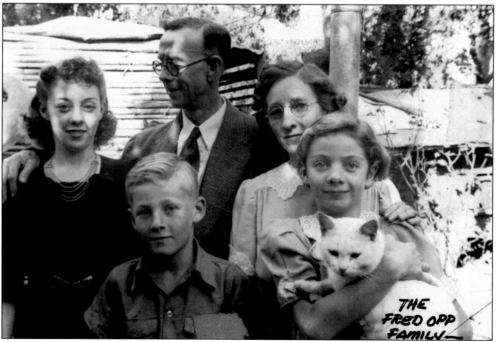

In addition to the gourd farm, Fred Opp was active in civic affairs, serving on the original board of the Costa Mesa School District and the chamber of commerce board. Opp family members shown here are, from left to right, Leah, Richard (front), Fred, Elsie, and Norma. (Courtesy of Richard and Shirlee Opp.)

The Grow Brown family settled in Costa Mesa in 1921 after returning from missionary service in China. At its peak, the Brown farm included 200 dairy cows and 800 acres leased from the Banning Company. This view of the Brown farm shows the dairy herd grazing on the Santa Ana River lowlands at the end of Victoria Street. The Browns sold their dairy to Harry DeWolfe in 1929.

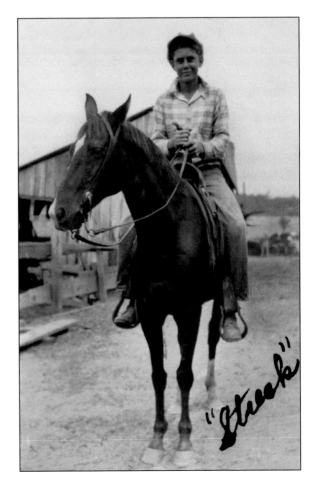

Shown in this 1927 photograph is Chisholm Brown mounted on the family horse, Streak. As a youth, Chisholm tended the herd, sometimes taking his horse onto the flooded lowlands to drive any stranded cows back to dry pasture. In later years, he would become a partner with Hugh Davis in the Davis-Brown appliance store and would serve on the local school board. (Courtesy of Chisholm Brown.)

Costa Mesa's first cop, Frank "Big Boy" Vaughn, demonstrates classic form in this 1925 photograph. The Orange County Supervisors had turned down Costa Mesa's request for a police officer, so the chamber of commerce secured the funds. Vaughn was seen most often behind the wheel of his stripped-down Ford giving chase to any motorist speeding through town.

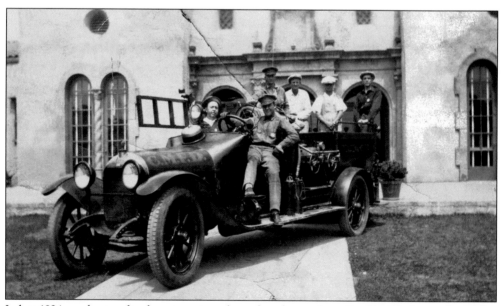

In late 1924, a volunteer fire department was formed, and soon thereafter, Fred Bush was elected fire chief. Again the chamber of commerce was at the center of action as they acquired the chemical wagon shown here. In 1929, volunteer firefighters included, from left to right, (first row) C. Lewis and B. Baker; (second row) unidentified, Emil Myrehn, E. Mellott, and Fred Bush.

Social and cultural activities received a boost with the construction of the Friday Afternoon Clubhouse on the west side of Newport Boulevard south of West Eighteenth Street. Dedication ceremonies were held on April 17, 1923. The club undertook various community projects, such as initiating a county branch library in Costa Mesa. The clubhouse is in use today as a commercial business at 1785 Newport Boulevard.

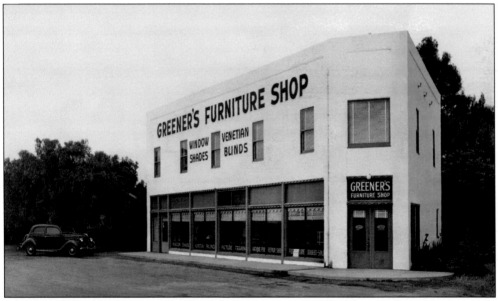

About 1925, Emil V. Greener opened a furniture store in a new building on the southeast corner of East Eighteenth Street and Newport Boulevard. After several years, he moved the business across Newport Boulevard and south a block to the building shown here. In this striking view, a small portion of the Friday Afternoon Clubhouse can be seen behind the trees between the automobile and the building. The Greener Building's second floor was used for social and community events.

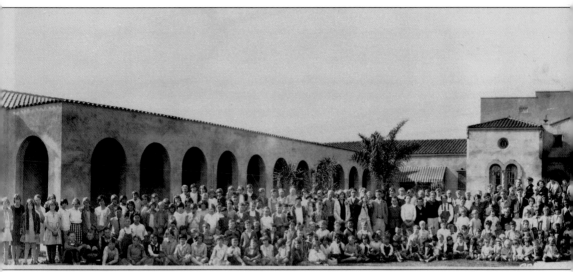

Rapid growth in the early 1920s triggered the need for larger school facilities. Costa Mesans took action. A 5-acre site on the northwest corner of Nineteenth Street and Newport Boulevard was selected, a $50,000 bond issue was approved, and school construction was begun by October

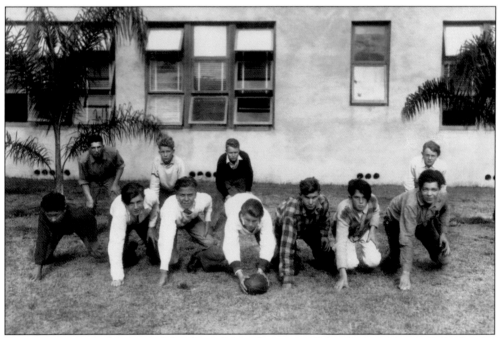

Sports were a popular part of the Costa Mesa Grammar School scene, particularly for the seventh and eighth graders. Pictured here is the 1926–1927 football team; Orville Northrup was their coach.

1922. The need for additional space was so acute that 36 pupils were moved to one room of the new school in March 1923 before the building was complete. In less than one year, another five-classroom addition was approved, funded, and contracted.

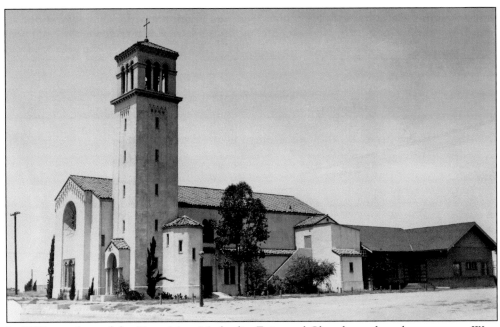

In 1925, members of the Costa Mesa Methodist Episcopal Church purchased property on West Nineteenth Street between Newport and Harbor Boulevards. They moved their existing church building (page 55, bottom) to the back lot and three years later built a new sanctuary in the Spanish Colonial Revival style (above, left). The old church behind the new sanctuary then was put to other uses such as Sunday school. The historic sanctuary has served as a city landmark since 1928. Today visitors are welcome to attend Sunday services at 420 West Nineteenth Street.

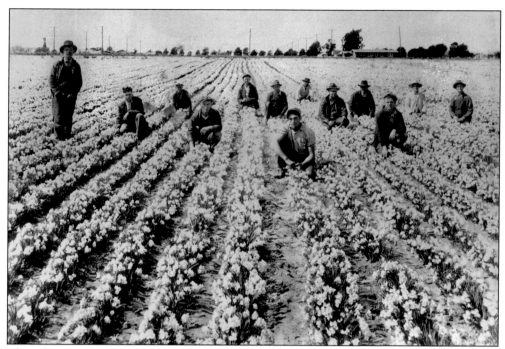

The February 10, 1927, edition of the *Costa Mesa Herald* reported, "Costa Mesa Takes Lead as Bulb Center of State." During the year prior to the newspaper article, M. A. Casad had shipped five million freesia, gladiola, and iris bulbs back to the eastern market. Casad (left), shown in one of his flower fields, had come to Costa Mesa in 1923 and increased his acreage of bulbs from 5 to 40 acres by 1927.

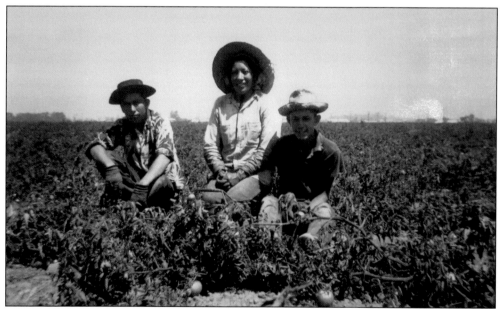

In spite of all the commercial growth and land development in the 1920s, Costa Mesa was still a farming community. Here Abelina Leon (center) and other members of the Gregory (Gregorio) Leon family work in their tomato field on Seventeenth Street in the Newport Mesa tract.

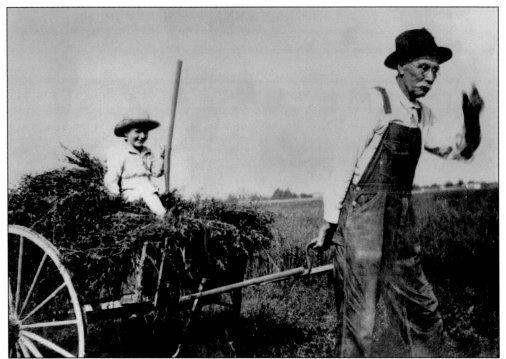

Even with mechanization of farming operations, hand labor was still in style. Pictured here around 1928 are James Bennett (right) and his grandson Ted Bennett enthusiastically making hay. The James Bennett family left Missouri in 1912 and lived in Downey for two years before moving to Harper.

James L. Pangle was a teamster who worked on many of the family farms in Costa Mesa to make ends meet. In this c. 1924 photograph, Pangle is seen driving a team hitched to a sickle bar mower in his field north of Wilson Street between Harbor Boulevard and Meyer Place. His wife, Loretta Pangle, was an accomplished seamstress who made Hawaiian shirts and other clothing items for prominent families, including the family of actor James Cagney.

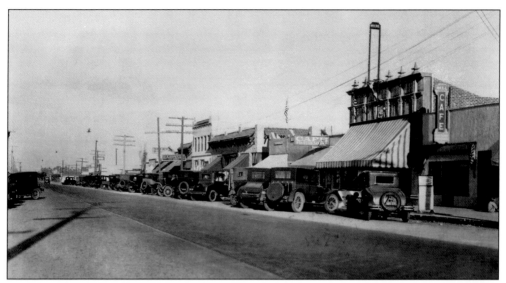

By the end of 1924, downtown Costa Mesa had taken on a gentrified look, with new storefronts replacing older ones. Compared to the downtown view shown on the bottom of page 81, Costa Mesa now had TeWinkle's Hardware, an Alpha Beta store, and a post office housed in its own building complete with the U.S. flag flying above.

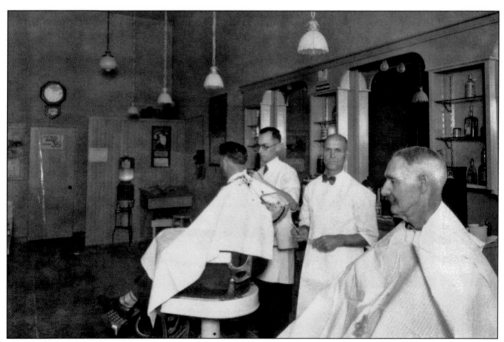

Lloyd Braddy's Barbershop was a downtown fixture, first located in the new Patterson Building on the southeast corner of Broadway and Newport Boulevard. The days of "shave and a haircut, two bits" had passed—the posted price had risen to 35¢. Other businesses sharing the building were a drugstore, Safeway grocery, and poolroom. See the bottom of page 102 for an outside view of the modern Patterson building in 1933.

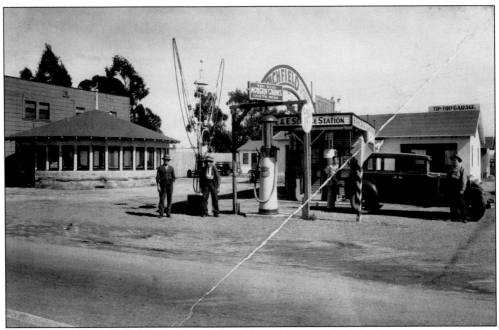

The E&E Service Station, located on the northeast corner of Rochester Street and Newport Boulevard, was owned and operated by David H. Elmer and Harold N. Elmer. When this photograph was taken in 1927, gasoline was 19.5¢ per gallon. Another element of roadside Americana evident is the combination of gas station and "modern" cabins.

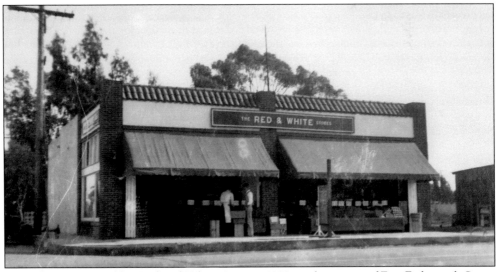

Albert Dudek opened his Red and White Store in 1929 on the corner of East Eighteenth Street and Newport Boulevard. Red and White was a chain of independently owned food stores operating in the United States. Dudek sold the business in 1944.

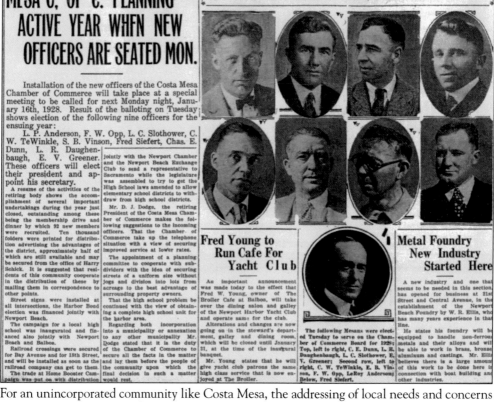

PHONES
Police700
Fire16
(D.. or Night)

Costa Mesa Hera

ONLY PAPER PRINTED IN THE HARBOR DISTRICT

VOLUME V

COSTA MESA, CALIFORNIA, THURSDAY, JANUARY 12, 1928.

MESA C. OF C. PLANNING ACTIVE YEAR WHEN NEW OFFICERS ARE SEATED MON.

Installation of the new officers of the Costa Mesa Chamber of Commerce will take place at a special meeting to be called for next Monday night, January 16th, 1928. Result of the balloting on Tuesday shows election of the following nine officers for the ensuing year:

L. P. Anderson, F. W. Opp, L. C. Slothower, C. W. TeWinkle, S. B. Vinson, Fred Siefert, Chas. E. Dunn, L. R. Daughenbaugh, E. V. Greener. These officers will elect their president and appoint his secretary.

A resume of the activities of the retiring body shows the accomplishment of several important undertakings during the year just closed, outstanding among these being the membership drive and dinner by which 92 new members were recruited. Ten thousand folders were printed for distribution advertising the advantages of the district, approximately half of which are still available and may be secured from the office of Harry Schick. It is suggested that residents of this community cooperate in the distribution of these by mailing them in correspondence to other points.

Street signs were installed at all intersections, the Harbor Bond election was financed jointly with Newport Beach.

The campaign for a local high school was inaugurated and financed also jointly with Newport Beach and Balboa.

Railroad crossings were secured for Bay Avenue and for 18th Street, and will be installed as soon as the railroad company can get to them. The trade at Home Booster Campaign was put on with distribution

Jointly with the Newport Chamber and the Newport Beach Exchange Club to send a representative to Sacramento while the legislature was assembled to try to get the High School laws amended to allow elementary school districts to withdraw from high school districts.

Mr. D. J. Dodge, the retiring President of the Costa Mesa Chamber of Commerce makes the following suggestions to the incoming officers. That the Chamber of Commerce take up the telephone situation with a view of securing improved service at lower rates.

The appointment of a planning committee to cooperate with subdividers with the idea of securing streets of a uniform size without jogs and division into lots from acreage to the best advantage of surrounding property owners.

That the high school problem be continued with the view of obtaining a complete high school unit for the harbor area.

Regarding both incorporation into a municipality or annexation to any other municipality Mr. Dodge stated that it is the duty of the Chamber of Commerce to secure all the facts in the matter and lay them before the people of the community upon which the final decision in such a matter would rest.

New Directorate of Costa Mesa Chamber

Fred Young to Run Cafe For Yacht Club

An important announcement was made today to the effect that Fred W. Young, owner of The Broiler Cafe at Balboa, will take over the dining salon and galley of the Newport Harbor Yacht Club and operate same for the club.

Alterations and changes are now going on in the steward's department, galley and dining room, which will be closed until January 21, at the time of the inaugural banquet.

Mr. Young states that he will give yacht club patrons the same high class service that is now enjoyed at The Broiler.

The following Mesans were elected Tuesday to serve on the Chamber of Commerce Board for 1928: Top, left to right, C. E. Dunn, L. R. Daughenbaugh, L. C. Slothower, E. V. Greener; Second row, left to right, C. W. TeWinkle, E. B. Vinson, F. W. Opp, LeRoy Anderson; Below, Fred Siefert.

Metal Foundry New Industry Started Here

A new industry and one that seems to be needed in this section, has opened for business at 21st Street and Central Avenue, in the establishment of the Newport Beach Foundry by W. R. Ellis, who has many years experience in that line.

He states his foundry will be equipped to handle non-ferrous metals and their alloys and will be able to work in brass, bronze, aluminum and castings. Mr. Ellis believes there is a large amount of this work to be done here in connection with boat building and other industries.

For an unincorporated community like Costa Mesa, the addressing of local needs and concerns was an uncertain process that relied on the civic spirit of individual landowners and business people. Attention to those needs and concerns took a major step forward with the formation of the Costa Mesa Chamber of Commerce in December 1922. The founding board of directors included several of the families pictured in this book: Spencer, Dodge, Huston, Miner, Waterman, Mellott, TeWinkle, Forbes, and Middleton. In addition to promoting the growth of commercial interests in town, the chamber also took action to hire the area's first police officer and to purchase a chemical engine for the community's volunteer fire department. The chamber's involvement in civic improvements can be seen in the names of committees they formed over the years: Sanitary Sewer; Parking, Highway, and Signs; Employment; Garbage Disposal; and Drainage. The board of directors shown above was installed in January 1928. They would have to deal with an annexation attempt by Santa Ana and later with the effects of the Great Depression.

Costa Mesa
ORANGE COUNTY CALIFORNIA

The Gateway — Newport Harbor

COSTA MESA
Offers You

: : : : :

An ideal place in which to live, where health producing
benefits are to be derived from a delightful
intercourse with nature—

* * * * *

In A COMMUNITY of culture, beauty, ideal climate,
and desirable environments—

* * * * *

Where the children will keep healty and happy.
Good Schools—Library—Churches.

* * * * *

Within a mile of the best beach on earth.
Opportunities for the worker.

* * * * *

Big Profits for the Investor.

* * * * *

Unusual Transportation facilities for the Manufacturer.

: : : : :

We Welcome You to
Costa Mesa, Orange County, California

: : : : :

CHAMBER OF COMMERCE,
Costa Mesa, California.

After the initial land developers sold their lots and moved on to new opportunities, the chamber of commerce continued to promote Costa Mesa far and wide. The brochure pictured here was one example. The cover artwork suggests changing aspirations, with industry, commerce, fine homes, and beach recreation all upstaging Costa Mesa's agricultural roots. Major selling points within the brochure were residential community, sports, climate, harbor development, wealth, trade center, stores, energy and transportation, schools, church, paved highways, library, civic organizations, and finally small farms and gardens.

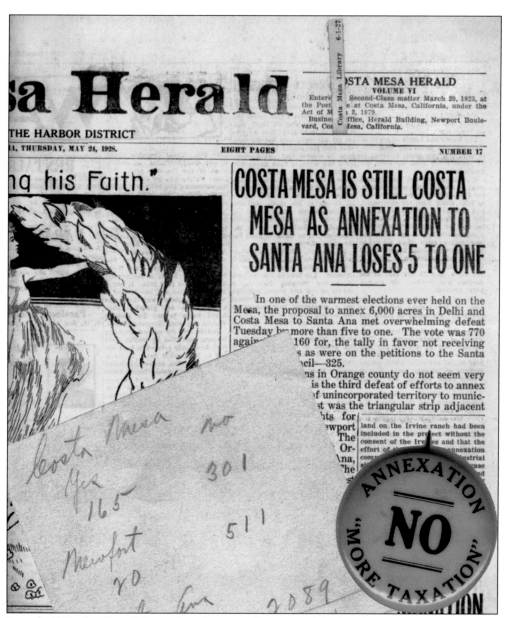

COSTA MESA HERALD
VOLUME VI
Entered Second-Class matter March 29, 1923, at the Post e at Costa Mesa, California, under the Act of M 3, 1879.
Busine ffice, Herald Building, Newport Boulevard, Cos esa, California.

sa Herald

THE HARBOR DISTRICT

A, THURSDAY, MAY 24, 1928. EIGHT PAGES NUMBER 17

ng his Faith."

COSTA MESA IS STILL COSTA MESA AS ANNEXATION TO SANTA ANA LOSES 5 TO ONE

In one of the warmest elections ever held on the Mesa, the proposal to annex 6,000 acres in Delhi and Costa Mesa to Santa Ana met overwhelming defeat Tuesday by more than five to one. The vote was 770 agair 160 for, the tally in favor not receiving s as were on the petitions to the Santa cil—325.

ns in Orange county do not seem very is the third defeat of efforts to annex f unincorporated territory to munic- st was the triangular strip adjacent hts for
wport land on the Irvine ranch had been The included in the pr ect without the Or- consent of the Irv es and that the Ana, effort of t nnexation he com strial ase d

In early 1928, the City of Santa Ana, having taken note of the bustling community just a few miles to the south, proposed to annex Costa Mesa. The election was set for May 22, 1928, with polling to take place at the Friday Afternoon Clubhouse on Newport Boulevard. The annexation proposal was voted down by a 5-1 margin as reported in the *Costa Mesa Herald* of May 24, 1928. In addition to the newspaper headline, the composite image above includes a well-used vote "NO" button and Donald Dodge's notation of preliminary precinct voting results.

Six

TIME OF TROUBLES

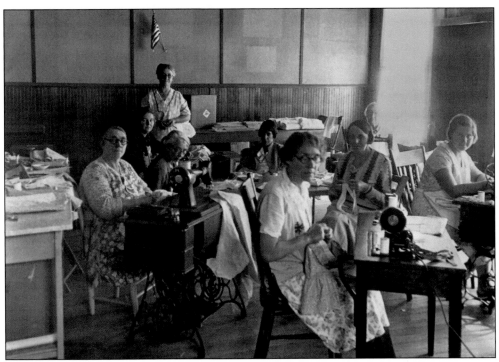

The Great Depression struck Costa Mesa just as surely as it did nearly every community in America. Businesses changed hands, banks closed, bills went unpaid, and people tightened their belts. Relief projects helped to make ends meet. Shown here is sewing work in the early to mid-1930s in a vacant store in Costa Mesa. In her oral history interview, Loretta Pangle recounted three and a half years of relief sewing work paid at a rate of 50¢ per hour.

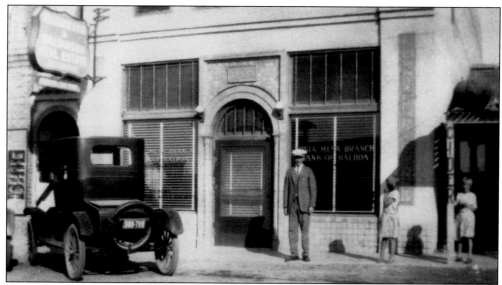

The Costa Mesa Branch of the Bank of Balboa closed its doors on Thursday, January 21, 1932. According to bank president Dr. F. C. Ferry, "We had excessive withdrawals Monday, Tuesday, and Wednesday of this week." It would be several years before Costa Mesa again had a bank in town. Shown in this 1924 photograph is assistant cashier L. R. Daughenbaugh standing in front of the bank in more prosperous times.

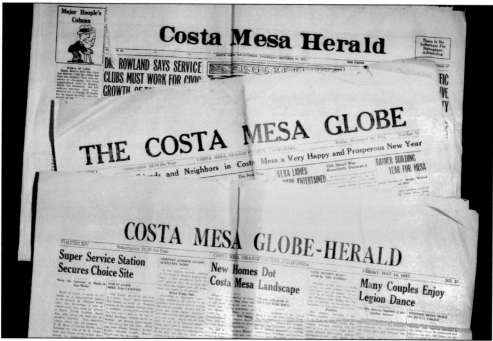

Since January 1923, Costa Mesa had its own newspaper, the *Costa Mesa Herald*. Then in 1934, competition appeared on the scene as the *Costa Mesa Globe* began publishing. Nearly two years later, *Globe* owner Len Martin bought the *Herald* and began publishing the *Costa Mesa Globe-Herald*. The *Globe-Herald* changed hands two more times in as many years and finally became the *Orange Coast Daily Pilot* in 1961. The *Daily Pilot* is still published today.

Aviation had come to Orange County, and flying continued in spite of the Depression. Shown here are neophyte pilot Luke Davis (left) and aircraft owner Carl Dooley preparing to leave the Eddie Martin Airport on a flight to San Diego in 1930. Davis's career as a pilot ended after the flight, but he became a well-known coach. Luke Davis Field is named after him.

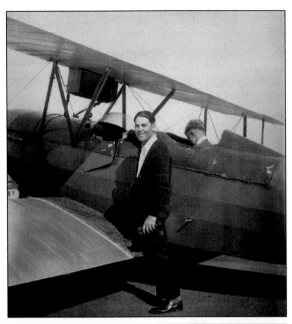

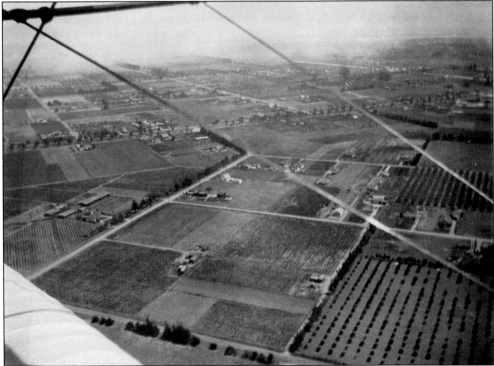

After taking off from Eddie Martin Airport, Luke Davis snapped this photograph of Costa Mesa in 1930. From this aerial viewpoint, the Depression does not appear to have impacted the array of small farms below. Newport Boulevard runs from center left at a slight angle to upper right. The three streets running from the right edge of the photograph upward to the left are, from front to back, Victoria, Hamilton, and West Bay Streets. These three streets meet Thurin Street toward the left side of the image.

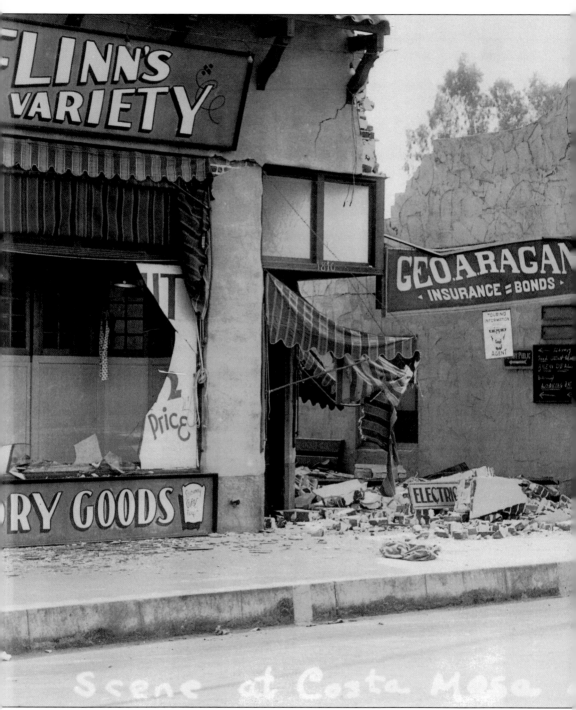

Scene at Costa Mesa

Although the Depression slowed things down in Costa Mesa, the city did not come to a halt—until 5:54 p.m. on Friday, March 10, 1933, when a severe earthquake shook Orange and Los Angeles Counties. Costa Mesa was hit hard. The epicenter was located about 4 miles southwest of Newport Beach along the Newport-Inglewood Fault. Buildings were severely damaged, but luckily there were no deaths in Costa Mesa. Shown here is the 1800 block of Newport Boulevard in the aftermath of

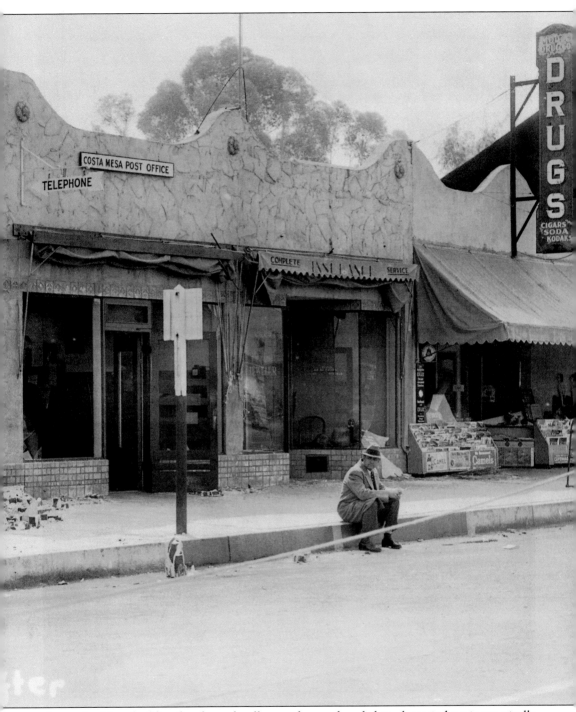

the quake. Many building facades and walls were damaged, and plate-glass windows in practically every storefront were shattered. As if oblivious to the disaster at hand, signs on the side of the post office building announced the latest books available at the Costa Mesa Branch Library, *A New Deal* by Stuart Chase and *Looking Backward* by Edward Bellamy.

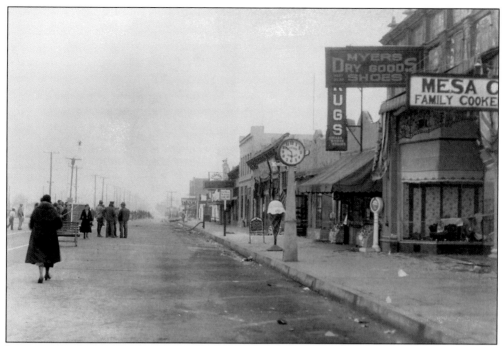

In a scene reminiscent of the 1951 sci-fi film *The Day the Earth Stood Still*, stunned Costa Mesans gather to look at their damaged downtown district. First responders are on the scene, while the hands of the Myers Jeweler clock stand still, indicating the time of the quake's onset.

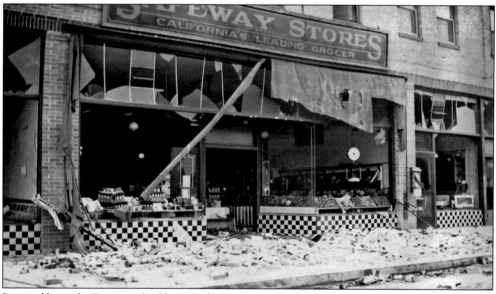

Pictured here, the Patterson building on the southeast corner of Broadway and Newport Boulevard was the most modern structure in town when it was erected in 1929. The Safeway store seems ready to sell canned goods and fresh produce—the scale is still hanging in the newly glass-free window. Immediately to the right, Lloyd Braddy's barbershop definitely had seen better days (see bottom of page 92).

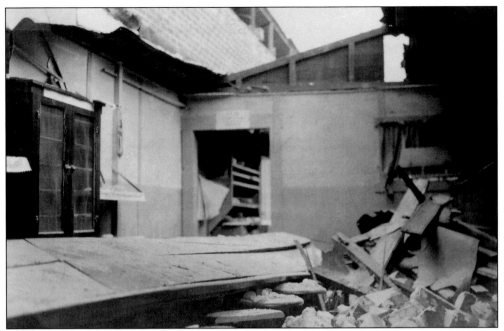

Falling bricks and debris from the adjoining two-story building may have exacerbated damage to the roof and interior of this downtown café and lunch counter. Even though the earthquake struck during the depths of the Great Depression, most businesses reopened either at the same location or at a new one close by.

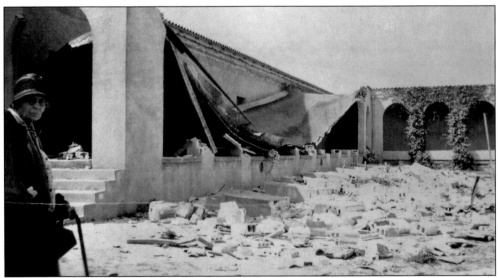

The Costa Mesa Grammar School suffered serious damage—how fortunate school was not in session. The extent of the damage was attributed in part to the use of hollow-core bricks such as those visible throughout the rubble in front of the school. The reaction of the townspeople to the earthquake was indicative of the community's vitality and perseverance. Within three months, the school board hired an architect, and by September 1935, the new school received its first pupils.

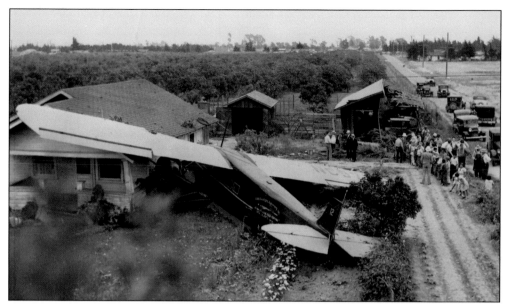

On June 5, 1935, a Stinson SM-6000 trimotor made this unscheduled landing at the Joe Volck residence on the northeast corner of West Bay Street and Harbor Boulevard. According to the *Santa Ana Register*, the aircraft lost power in all three engines and the pilot attempted a forced landing in a field next to the house. There were no serious injuries, except for the Volck family dog that was crushed beneath the wreckage. The house was pushed 2.5 feet off of its foundation.

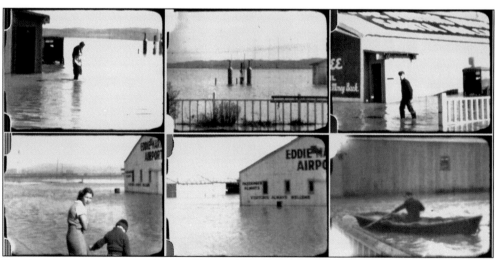

Floods were no strangers to Orange County. The February 19, 1937, *Costa Mesa Globe-Herald* reported million-dollar damage from the then-receding flood. The composite image above shows the effect of the February 1937 flood on Eddie Martin's Airport located just east of the intersection of today's 55 and 405 Freeways. The individual images were captured from frames of an 8-mm home movie.

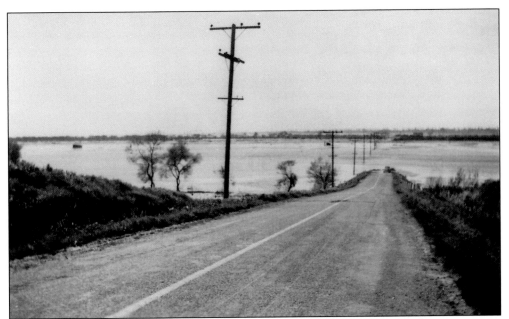

Just as Costa Mesans were seeing the end of the Great Depression, they were deluged by a series of rainstorms. Water poured down for a week, releasing a flood that peaked on March 3, 1938. In this view from Adams Avenue looking west, the roadway ends in the muddy torrent of the Santa Ana River; flooding is evident all the way to the horizon.

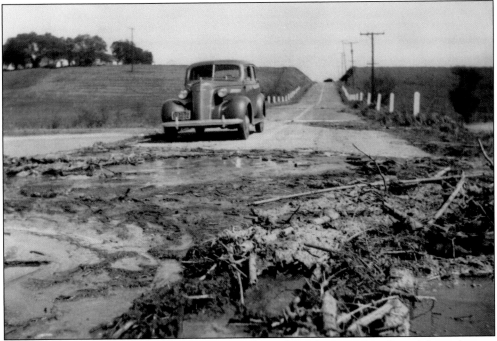

The reverse angle of the photograph above is shown here, looking east along Adams Avenue toward the mesa from the floodwaters' edge. To the left on the ridge are the Diego Sepulveda Adobe and accessory outbuildings. Also evident are some of the grand old pepper trees that still shade the adobe today.

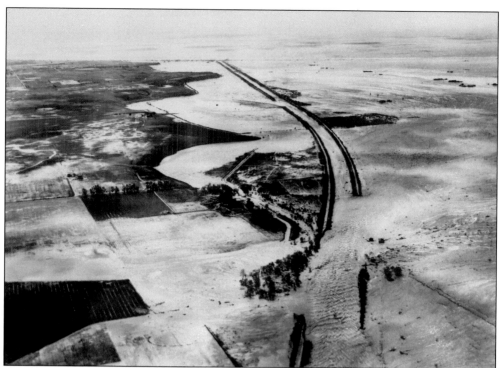

With 2,800 square miles of Santa Ana River watershed and an 11,000-foot elevation drop, scenes such as this serve as a reminder of Mother Nature's power. This March 1938 scene downstream from north Costa Mesa to the Pacific Ocean clearly shows levee breaches on both sides of the river. One can see why Native Americans placed their villages up on the mesa thousands of years ago.

The Santa Ana River lowlands were used for agricultural purposes, such as pasturing cows at the Brown Dairy (page 85, top) or growing crops as shown here. In this photograph, Irving Meyer (left) and Fred Brace survey their lowland cabbage patch south of Adams Avenue before the 1938 flood. After the flood, crops were poor because of the large amount of deposited silt. In his oral history interview, Irving Meyer remembered that after the 1938 flood, he had dug down as much as 9 feet to reach the rich soil he had previously cultivated.

Seven

THE STAGE IS SET

Of major significance to Costa Mesa, the formation of a local Lions Club in 1927 gave birth to a community service group that ever since has served as a city booster and rallying point for civic activity. In the above *c.* 1932 photograph, Lions Club president Charles Dunn (seated center, wearing cap) leads the group in painting the first parking stripes downtown.

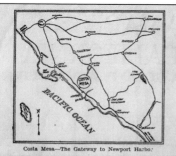

Costa Mesa—The Gateway to Newport Harbor.

STREET MAP
COSTA MESA
ORANGE COUNTY, CALIFORNIA
Published 1931 By
Chamber of Commerce
Costa Mesa, California

FINE HOMES———GOOD SCHOOLS

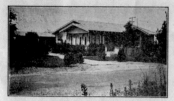

A Residence on Magnolia Street

A GOOD PLACE TO LIVE

Costa Mesa is essentially a residential community located within walking distance of the ocean and Newport Bay and only a few minutes drive to the mountains.

With two large elementary schools, a $410,000 High School plant, a $40,000 Community Church and hundreds of residences such as are pictured on this page Costa Mesa is fastly becoming one of California's most popular Home Communities.

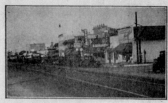

Costa Mesa Business Section

Charles Lindbergh Elementary School

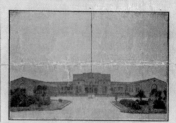

Harper-Fairview Elementary School

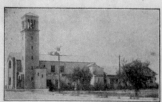

Costa Mesa Community Church

Newport Harbor Union High School

An Attractive Court on 18th Street

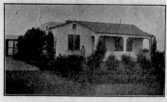

Well Kept Home and Garden on Wilson Street

The chamber of commerce continued promoting the area—for example, via this 1931 Costa Mesa street map. Notable here is the addition of two new schools, Lindbergh Elementary School and Newport Harbor Union High School. Gone completely is any mention of small farms and chicken ranches. Allegedly, Costa Mesa had become a bedroom community within "walking distance of the ocean and Newport Bay."

Whether or not Costa Mesa had actually become a predominantly residential community by the early 1930s, the trend was unmistakable. In this 1932 scene, Claire Hommel rides her bicycle in front of 595 West Wilson Street. However, part of an orchard can be seen to the left behind Claire's back. Agriculture would not be finished in Costa Mesa for many years to come. (Courtesy of Joyce Brown.)

Organized youth activities enjoyed increasing popularity in town. Shown here is a group of Camp Fire Girls meeting at the Rochester Street home of Costa Mesa's dentist, Dr. Clarence Huston, on April 12, 1937. The girls pictured here include, in no particular order, Lottie Rogers, Loretta Howe, Phyllis Joiner, Dorothy Dickerson, Joan Jordan, Madeline Milburn, Marilyn Braddy, Virginia Brown, and Alice Ramsey.

109

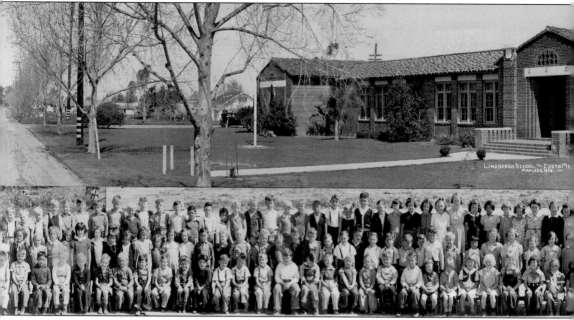

In 1930, as the Great Depression was settling in, Costa Mesa went ahead with building a new school to address growing enrollment. Charles A. Lindbergh was still riding a wave of popularity from his 1927 flight across the Atlantic, so the new school was named in his honor: Lindbergh

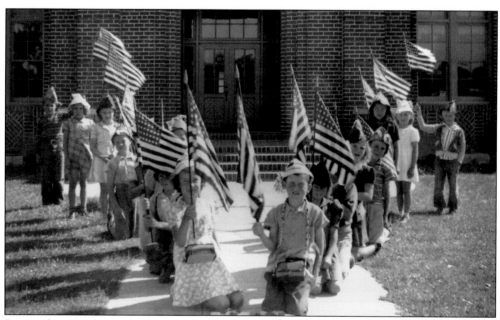

During the 1939–1940 school year at Lindbergh School, Viola Tummond's first-grade pupils waved their flags perhaps in observance of Armistice Day, which had just been made a federal holiday in 1938. Richard Opp is positioned on the right at the end of the "V." (Courtesy Richard and Shirlee Opp.)

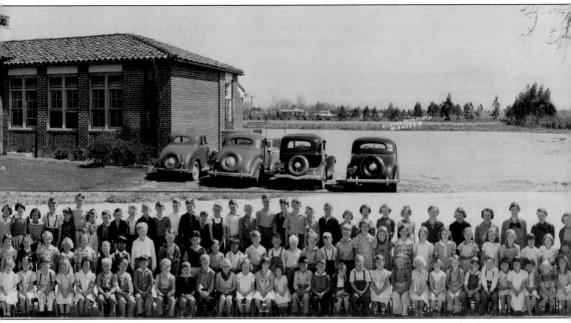

Grammar School. The school opened in 1931 on the north side of East Twenty-third Street at Orange Avenue in the Santa Ana Heights tract. When the above panoramic photograph was taken in 1938, school enrollment was about 180 pupils.

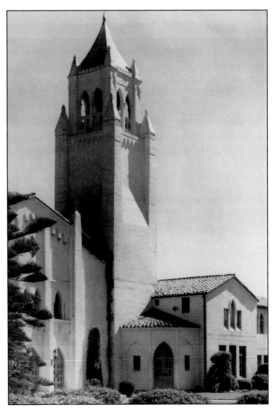

The Newport Union High School District was formed in September 1929, and within five months, a $410,000 bond issue was passed by Costa Mesa and Newport Beach area voters. The school opened in September 1930 with wet paint on the walls and no heat. Nevertheless, area students now had a local high school. This c. 1932 photograph of Robbins Hall shows the school's Spanish Gothic architecture and landmark clock tower. Lamentably, Robbins Hall was demolished in 2007. (Courtesy of Newport Harbor High School.)

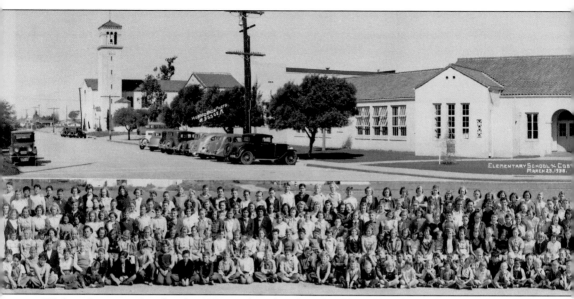

Within three months after the 1933 earthquake, the school board had hired an architect to draw up plans for a new building to replace Costa Mesa Grammar School, which had been damaged beyond repair (page 103 bottom). Students attended their first classes in the new building in September 1935. The 1938 panoramic view above shows the school at the northwest corner of Newport Boulevard and West Nineteenth Street, with the Costa Mesa Community Church

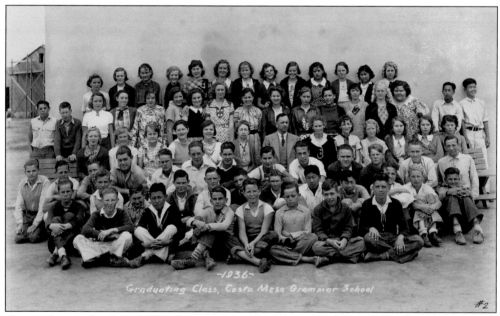

Shown above is the class of 1936, the first class to graduate after the new school building opened. Although the class includes Hispanic and Japanese students, they would have attended the separate Monte Vista School through grade six before matriculating to Costa Mesa Grammar School for grades seven and eight. Monte Vista School closed in 1942, although it would be five years before *Mendez v. Westminster* ended the practice of segregated schools throughout California in 1947.

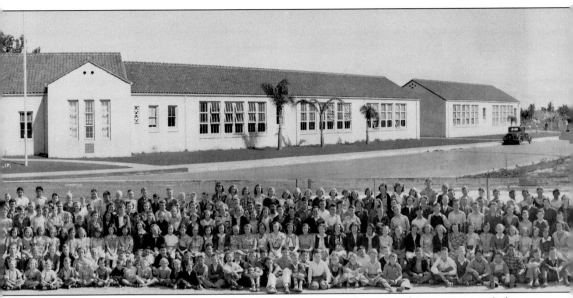

farther down Nineteenth Street to the left. The new school remained in service until about 1980 under several names: Costa Mesa Grammar School, Main School, and McNally School. Finally the campus was used as an alternative high school before being demolished to make way for downtown redevelopment.

The town was proud of its Costa Mesa Grammar School basketball team for winning the Orange County championship in 1938. From left to right are (kneeling) Bill Goochey, Chuck Hoffard, and Akira Uetchi; (standing) Henry Abrams (superintendent of schools), Preston Joiner, Jack Hartley, Harold Sheflin, John Shilling, unidentified, Charles "Bud" Lanning, and Bill Crow (coach).

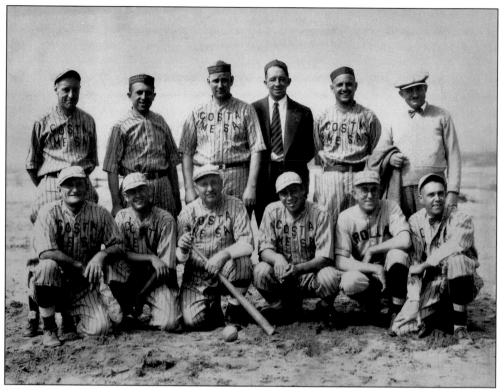

Schools were not the only organizations fielding sports teams. Pictured here is the Costa Mesa Lions Club softball team in 1931. From left to right are (first row) George Gardner, Ed Chaplin, A. E. Spaulding, Earl Patterson, Fred Siefert, and Charles TeWinkle; (second row) Charles Dunn, Emil Greener, Ross Hostetler, Judge C. B. Diehl, Ray Wallace, and Alvin Block.

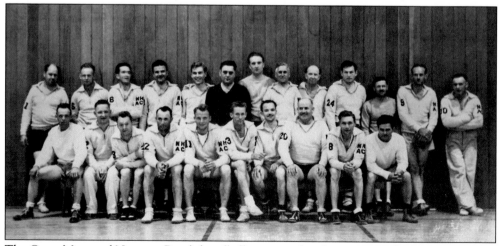

The Costa Mesa and Newport Beach handball teams took a few minutes of court time to pose for this group photograph around 1934. The teams met at Newport Harbor Union High School. Handball continues to be popular in the area today.

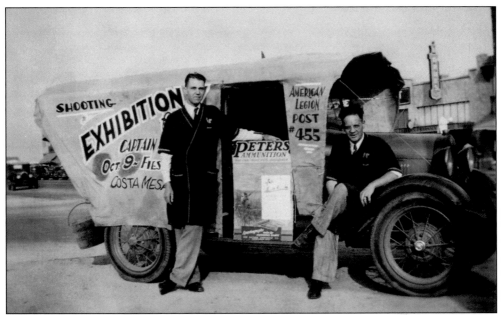

Costa Mesa formed its first American Legion Post in May 1932. Post No. 455 wasted no time in planning and promoting its first big event, the Fiesta del Oro, to be held north of town on the Derby ranch. The fiesta theme was "Old Spanish Days" and included a parade, Spanish sports, and entertainment under the direction of Sol Gonzales of Santa Ana. In this photograph, Charles TeWinkle (left) and a fellow legionnaire have set up their Model A covered wagon on Newport Boulevard to promote the upcoming fiesta.

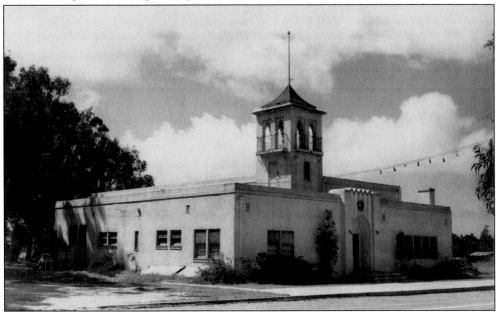

After several years of planning and delay, construction of the Costa Mesa American Legion Hall began in late 1937. The building carried a contemporary look, borrowing elements from art moderne and other architectural styles. Located at 565 West Eighteenth Street, the building served local veterans until it was demolished in the 1980s.

In November 1929, Donald J. Dodge succeeded A. H. Wilson as justice of the peace for the Costa Mesa area. Judge Dodge is shown here around 1939 at the corner of Harbor Boulevard and Balboa Street where he had placed his "shingle." (Gone today, Balboa Street ran west from the intersection of Newport and Harbor Boulevards to Anaheim Avenue.) Judge Dodge also was instrumental in establishing the Newport Harbor Union High School District and, later, the Orange Coast Junior College District.

Following the sign at Harbor Boulevard two blocks west to Anaheim Avenue, one would arrive at Judge Donald Dodge's courthouse and real estate office. He held court in this modest building until the early 1950s before moving to a new building adjacent to the American Legion Hall at 565 West Eighteenth Street. Judge Dodge held office for the next 29 years until his retirement in 1959.

Children were not the only ones receiving education in Costa Mesa. Pictured above are participants in an adult education class taught by Minnie V. Reid around 1935. This particular group is taking a naturalization class prior to applying for U.S. citizenship. Judge Donald Dodge (back row, second from left) posed with the class—perhaps these students would be admitted to citizenship in Judge Dodge's courtroom.

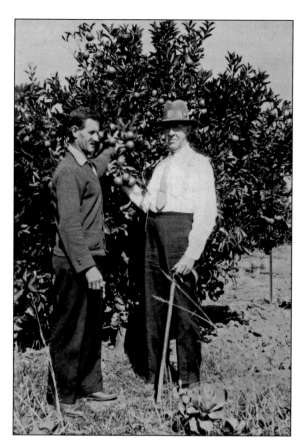

Due to a combination of warmer winters and pestilence, apple growing died out in Costa Mesa by the late 1920s. However, citrus continued to thrive. Pictured here are Joe Volck (left) and a neighbor, George Lowe, taking a look at Volck's orange trees in 1930. The extent of the Volck orange grove, located on the northeast corner of West Bay Street and Harbor Boulevard, can best be seen in the photograph on the top of page 104. Evidently, agriculture was still alive and well in Costa Mesa.

Water continued to be of critical importance to the area. The four major tracts—Newport Heights, Newport Mesa, Fairview Farms, and Santa Ana Heights—operated separate water companies. Shown here is a stock certificate issued in 1936 to James and Loretta Pangle for three shares, according to the 3 acres they owned. Eventually, the first three water districts listed above, along with the later-formed Costa Mesa City Water Department, would combine to form today's Mesa Consolidated Water District.

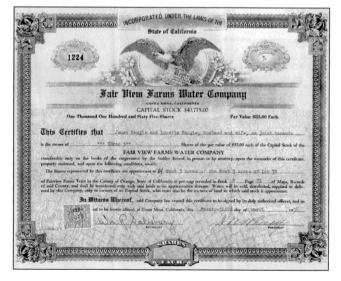

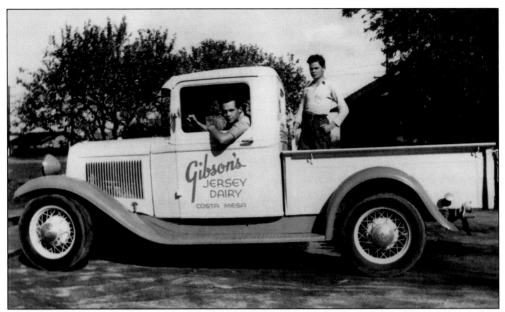

Donald and Edna Gibson moved to Harper in 1919 and farmed a 10-acre lemon grove. Soon they converted their acreage to a dairy and began selling milk locally. Don Gibson also drove a school bus, graded county roads, and opened a filling station on the southwest corner of Bernard Street and Harbor Boulevard, close to downtown Costa Mesa. In the mid-1930s photograph above, Donald Gibson's sons, Marvin (left) and Arthur, are preparing to deliver milk to customers. The dairy operated until 1943 when the boys went off to war.

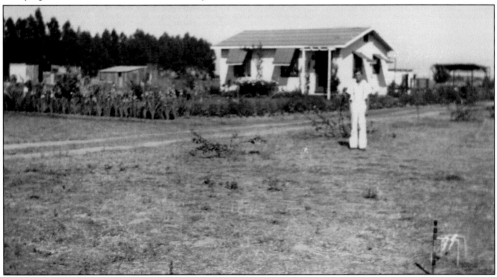

The David Johnson Gardner Jr. family settled on 2 acres on the northeast corner of Twentieth Street and Newport Boulevard in 1937. The Gardners ran a ranch of up to 4,000 chickens before going into the printing business in 1947. Their roadside stand at 2028 Newport Boulevard was open Thursdays to Sundays, selling eggs, dressed chickens, and produce to passersby. Shown above is Gardner's son, Dave Gardner, age 10, standing in front of the family ranch house. The house was set back from Newport Boulevard about 75 yards, leaving ample room for the lawn croquet court visible in the foreground. (Courtesy of Dave Gardner.)

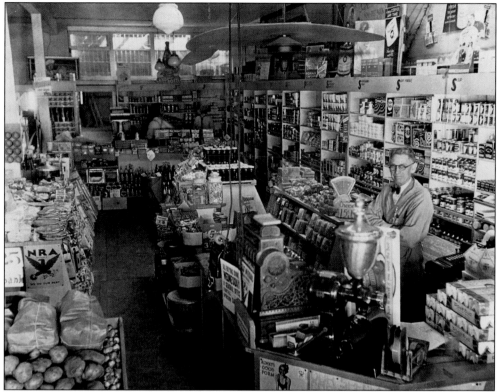

To townsfolk, the Alpha Beta Market at 1806 Newport Boulevard represented corporate commitment to young Costa Mesa. The 1934 photograph above shows the manager of Alpha Beta No. 13, C. Grant Illingworth, in his well-stocked store. Prominently displayed toward left center is the Blue Eagle symbol of the National Recovery Administration with its slogan, "We Do Our Part." Also evident in this Depression-era image are steel bars across the rear store windows to deter pilferage.

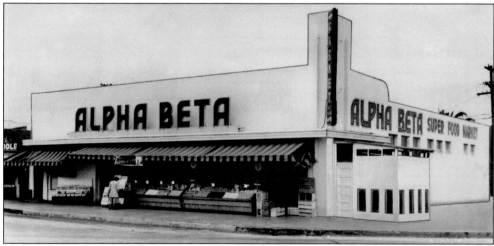

In July 1939, after three years of rumors and counter-rumors, Costa Mesa had its first supermarket. The Alpha Beta store moved from its original location at 1806 Newport Boulevard across the street to a new location on the southwest corner of Balboa Street and Newport Boulevard. Again, Alpha Beta had made a significant investment in Costa Mesa.

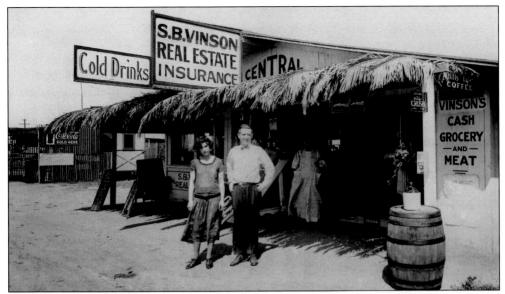

Family-owned and operated businesses still were predominant in town, even with the presence of chains such as Safeway and Alpha Beta. Pictured here are Mae B. Vinson (left) and her husband, Sylvanus B. Vinson, in front of their cash grocery and meat, real estate, and insurance business at 2214 Newport Boulevard.

One of Costa Mesa's local businessmen, Charles TeWinkle, opened his hardware store at 1818 Newport Boulevard in October 1922. By 1938, the store had become an appliance and hardware emporium. The photograph above, taken during the 1938 Christmas season, shows TeWinkle demonstrating new technology—the Philco Mystery Control. With the introduction of wireless remote control, could the era of the couch potato be far off?

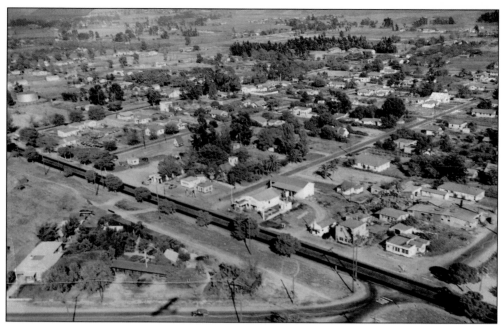

In this aerial view taken about 1939, Fairview Road runs across the bottom, while Newport Boulevard runs diagonally across the image from center left to lower right. The streets intersecting Newport Boulevard are, from left to right, Twenty-third Street, Albert Place, Cecil Place, and Virginia Place at the lower right corner. On the northeast corner of Cecil Place and Newport Boulevard is the Mackenzie filling station with the Mackenzie home immediately behind. On the southeast corner is the Nelson Feed Store.

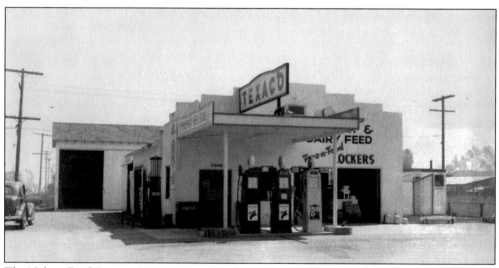

The Nelson Feed Store at 2240 Newport Boulevard featured livestock feed, Froz-n-Food lockers, and at least two grades of Texaco gasoline. Another feature of American filling stations appears to the right—a restroom.

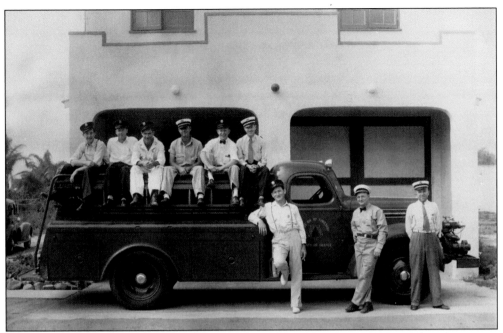

In 1936, a volunteer fire department was formed to man a new fire engine delivered by the county, and less than three years later, a new fire station on Rochester Street was dedicated. Fire department members shown above in September 1939 are, from left to right, B. Smith, G. Almond, Al Ogden, L. Walker, Edwin Edick, L. Fisher, L. Collins, John Powers (captain), and Emil Greener.

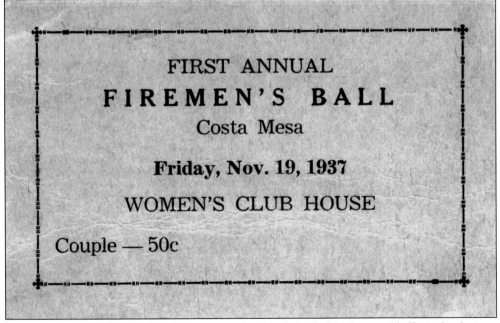

FIRST ANNUAL
FIREMEN'S BALL
Costa Mesa

Friday, Nov. 19, 1937

WOMEN'S CLUB HOUSE

Couple — 50c

Costa Mesa's new volunteer fire department soon decided to hold a fireman's ball as a fund-raiser. The first annual event was held at the women's clubhouse on Newport Boulevard in November 1937. The second annual ball in 1938 was held the same evening as the dedication of the new fire station—with one change from the 1937 ball—ladies were admitted free.

Costa Mesa had endured its time of troubles and emerged unbroken. One example of community spirit was the Scarecrow Festival sponsored by the chamber of commerce. The first festival was held just three months after the March 1938 floods and attracted 5,000 people. The 1939 event attracted an estimated 20,000 spectators, five times the population of Costa Mesa. Shown here is the 1939 scarecrow entry of Viele Brothers Plumbing, entitled "The Men of Fittings."

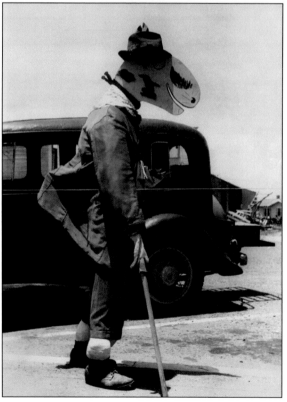

The 1939 Scarecrow Festival featured a parade and street dance as well as the scarecrow contest. *Look Magazine* and national news services covered the event. The scarecrow entry shown here serves as a reminder of the farm draft horses that had served local farmers in past years.

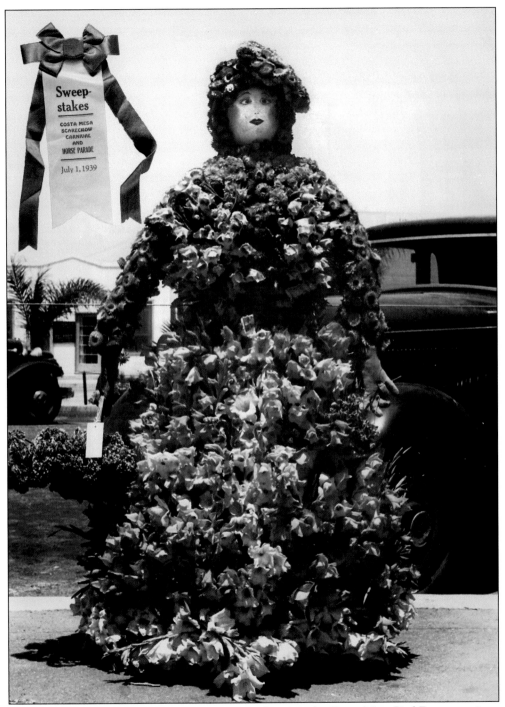

One of the 1939 scarecrow contest winners was this entry by Costa Mesa Bird Farm proprietor M. G. Eighmey and his daughter Virginia. Their blue ribbon scarecrow was entitled "Flora." Although the annual event was off to a strong start, the Scarecrow Festival ended after 1941 with the United States entry into World War II.

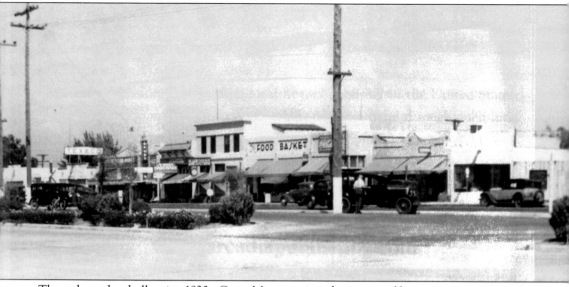

Throughout the challenging 1930s, Costa Mesa continued to grow and began to assume a unique identity and personality. The community's response to problems was spirited. For example, when the Southern Pacific branch line running down the center of Newport Boulevard was abandoned and the tracks ripped up, the Women's Club undertook a beautification project. When completed,

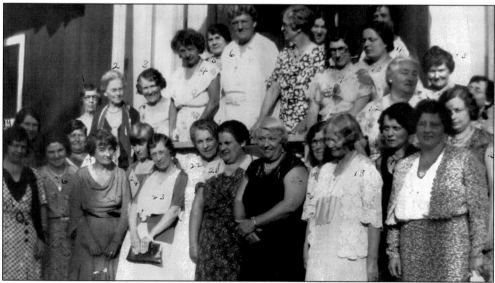

Shown here is a mid-1930s gathering of the Friday Afternoon Club hosted by Mrs. L. R. Daughenbaugh (no. 29, second from left). By 1939, the club had formed sections—arts and crafts, music, baby clinic, garden, and bridge. However the external impact of the group lay in community improvements such as the initiation of library service and the downtown beautification project pictured at the top of this page. The women's clubhouse served as a meeting place for other local groups and for town hall meetings and as a polling place in elections. The Friday Afternoon Club changed its name to the Costa Mesa Women's Club in 1962. The group continues to be active in community affairs today.

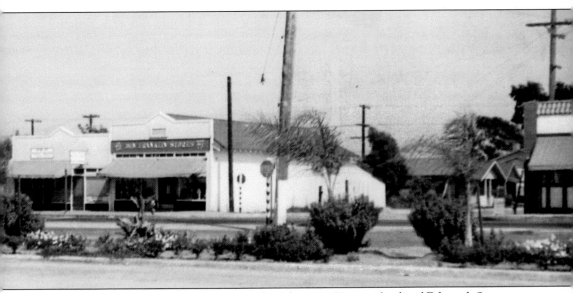

a one-half-mile stretch of the former right-of-way between Twenty-third and Fifteenth Streets was planted with palms, shrubs, and flowers. The c. 1937 panoramic view above shows the downtown segment of the project. George R. Breiner photographed the scene in two exposures using a 35-mm camera and recently introduced Kodak Panatomic film.

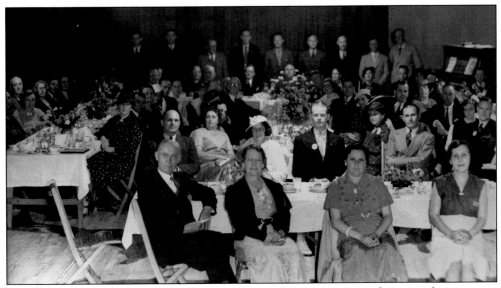

By 1939, Costa Mesa had moved from a community of Native American hunter-gatherers to one of modern family farms supported by a thriving downtown district. Between these times, Costa Mesa had seen the passing of Spanish, Mexican, rancho, grain-farming, and apple-growing eras. The community had survived floods, pestilence, earthquakes, and the Great Depression. What would the future hold? It would be the people of the community, such as those shown here at a Lions Club Grand Banquet, who would energize the community throughout World War II, the postwar boom, city-hood, freeways, shopping centers, performing arts, and more. But that is a story for another day.

DISCOVER THOUSANDS OF LOCAL HISTORY BOOKS FEATURING MILLIONS OF VINTAGE IMAGES

Arcadia Publishing, the leading local history publisher in the United States, is committed to making history accessible and meaningful through publishing books that celebrate and preserve the heritage of America's people and places.

Find more books like this at
www.arcadiapublishing.com

Search for your hometown history, your old stomping grounds, and even your favorite sports team.

Consistent with our mission to preserve history on a local level, this book was printed in South Carolina on American-made paper and manufactured entirely in the United States. Products carrying the accredited Forest Stewardship Council (FSC) label are printed on 100 percent FSC-certified paper.

MADE IN THE
USA